Growing Up in
SAN FRANCISCO'S
WESTERN NEIGHBORHOODS

Growing Up in SAN FRANCISCO'S WESTERN NEIGHBORHOODS

BOOMER MEMORIES FROM KEZAR STADIUM TO ZIM'S HAMBURGERS

Frank Dunnigan (signature)

FRANK DUNNIGAN

THE History PRESS

Published by The History Press
Charleston, SC 29403
www.historypress.net

First published 2014
Second printing 2014

Manufactured in the United States

ISBN 978.1.62619.384.0

Library of Congress Cataloging-in-Publication Data

Dunnigan, Frank.
Growing up in San Francisco's western neighborhoods : boomer memories from Kezar
Stadium to Zim's Hamburgers / Frank Dunnigan.
pages cm
Includes bibliographical references and index.
ISBN 978-1-62619-384-0
1. Dunnigan, Frank--Childhood and youth. 2. San Francisco (Calif.)--Social life and
customs--20th century. I. Title.
F869.S35D86 2014
979.4'61053092--dc23
[B]
2014026311

*To my
parents,
grandparents,
great-grandparents,
aunts, uncles, cousins,
friends, neighbors and co-workers
who came together in a time and a place
that enabled all of us to share lives and memories
of growing up in San Francisco.*

"The backyards and the schoolyards and the trees that watched us grow,
The days of love when dinnertime was all you had to know…"

—Art Garfunkel, *"Just Over the Brooklyn Bridge"*

CONTENTS

CONTENTS

FOREWORD

S an Francisco is changing…again.

Techies are buying Doelger-built houses for $1 million, even though the 1940s asking price was about $5,000 and, until the early 1980s, the cost was generally under $100,000. A plague of artisanal grilled cheese sandwich cafés is overrunning South-of-Market and the Mission. There are more dogs than children in the city, and I hear almost daily that young, rich, skinny jean–wearing, bicycling hipster-techies are chasing teachers, social workers and grandmothers right out of town.

Fear not. Just as Jeannette MacDonald sang that San Francisco lets no stranger wait outside its door, Frank Dunnigan's writing reminds us that for all the churning of change since the pueblo of Yerba Buena became the city of San Francisco, the small-town spirit is still being kept alive and well—and passed on down.

If you live here long enough, you will feel that you know almost everyone, or at least that you went to school with their sister. I guarantee that a good percentage of the recent newcomers will stay and that their children will fondly remember four-dollar toast and Matcha green tea lattes the same way we old-timers occasionally crave an "It's-It" or a brick of stale, cellophane-wrapped pink popcorn from Playland.

Frank's tasty nuggets of neighborhood nostalgia are the perfect mix of honey, bittersweet chocolate and a sprinkling of sea salt from a foggy Western Neighborhoods day. He vividly brings back the most obscure details

that you forgot you had forgotten, makes you happy to remember what has been lost and leaves you not grouchy but appreciative that you have been a part of a great city's history.

WOODY LABOUNTY
Co-Founder, Western Neighborhoods Project

ACKNOWLEDGEMENTS

With the good fortune to have been born at the midpoint of the last century, I was able to know many San Franciscans from the gas-lit, horse-and-buggy era. My Dunnigan great-grandparents were married in San Francisco in 1862, and their firstborn, my grandfather's older sister, arrived in 1863, when her parents lived in the South-of-Market neighborhood. I have clear memories of her when I was a child in the 1950s and she was in her nineties.

My grandparents were all born between 1872 and 1891, so growing up in a family like this, with many aunts, uncles and older cousins, I became the recipient of countless family stories with a depth of historical details. Every family outing included multiple conversations that began with, "Remember when…" as the speaker pointed out something along the drive to our destination and again on the way back home.

September 1, 1948, was the fortuitous date when my parents, married for just one year, bought their first and only home on 18th Avenue in the Parkside District. That decision helped to form the basis for many of my future experiences. My sincere thanks go to that home's original owners for selling precisely when they did more than sixty-five years ago—it made all the difference in the world to our family.

To my teachers—both lay and religious—plus innumerable schoolmates and co-workers throughout the years, all of whom have contributed in various ways to the stories that follow, I am truly grateful—for the learning, friendship and experiences that we have enjoyed together. Likewise, to my

three godchildren and their children, countless thanks are due for keeping me informed and up to date on exactly how life is continuing to evolve for all of us in this second decade of the new millennium.

My sincere appreciation also goes to Woody LaBounty and David Gallagher, founders of the Western Neighborhoods Project (WNP), for encouraging me to consolidate my thoughts into a monthly column called "Streetwise," which they have published continuously on the WNP website (http://www.outsidelands.org/index.php) since January 2009. This book includes several of those columns, often in an expanded or modified form, plus many brand-new items. My appreciation also goes to Woody and David for their help in assembling many of the photographic images from the vast WNP collection.

Finally, thanks to all those individuals who contributed to this book with their anecdotes, experiences, observations, leads on new sources, fact-checking, proofreading, one-of-a-kind photos and general camaraderie: Tim Adams, Paul Albert, Tammy Aramian, Rex Bell, Alan Brimm, John Byrne, Kathy Bertsch Compagno, Jim Dekker, Eric Faranda, Eric Fischer, John Freeman, Vivian Gisin, John Gross, Martha Harmssen, Judy Hitzeman, Bernadette Hooper, Paul Judge, Christine Meagher Keller, Aubrie Koenig, Mary Anne Kramer, Betty Lew, Richard Lim, John Martini, Joseph McInerney, Robert Menist, Wayne Miller, Nestor Nuñez, Dennis O'Rorke, Mary-Ann Orr, Alyssa Pierce, Rick Prelinger, Jo Anne Quinn, Paul Rosenberg, Linda Moller Ruge, John Paul Sant, Debbie Schary, Brad Schram, Alice Ho Seher, Rita Ann Smith, Jeff Thomas, Jack Tillmany, Paul Totah, Paul Trimble, Lorri Ungaretti, Grant Ute, John Vallelunga, John and Linda Westerhouse and Debbie Woodall.

THE NEIGHBORHOODS

Depending on the list-maker, the Western Neighborhoods alone consist of seventy individual enclaves, developments, tracts, sections, areas, clusters and sub-neighborhoods. Those involved in real estate have recently begun inventing dozens of new names citywide (Baja Noe, anyone?).

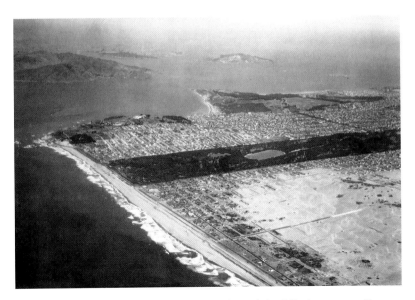

In the 1920s, the Richmond District was largely settled, while there were still many sand dunes in the Sunset District, and the Golden Gate Bridge was not yet built. *Wayne Miller Collection.*

Anza Vista
Ardenwood
Balboa Park
Balboa Terrace
Clarendon Heights
Country Club Acres
Crestlake
Ewing Terrace
Forest Hill
Forest Hill Extension
Forest Knolls
Galewood Circle
Ingleside
Ingleside Terraces
Inner Richmond
Inner Sunset
Jordan Park
Laguna Honda
Lake Merced Hill
Lakeshore
Lakeside
Lake Street
Land's End
Laurel Village
Little Russia
Lone Mountain
Loyola Terrace
Merced Heights
Merced Manor
Midtown Terrace
Miraloma Park
Monterey Heights
Mount Davidson
New Chinatown (Clement Street)
North of Lake Street
Ocean Beach
Oceanview
Outer Parkside

Outer Richmond
Outer Sunset
Parkmerced
Park Presidio
Parkside
Parkway Terrace
Parnassus Heights
Pine Lake Park
Presidio
Presidio Terrace
Richmond
Sea Cliff
Sherwood Forest
Shoreview Terrace
Stern Grove
St. Francis Wood
Stonestown
Sunnyside
Sunset
Sutro Heights
Twin Peaks
UC-Med
University Park-North
University Park-South
University Terraces
Upper Market
West of Twin Peaks
West Portal
Westwood Highlands
Westwood Park
Windsor Terrace

DO YOU REMEMBER...?

- Finger painting, Play-Doh, Silly Putty and Mr. and Mrs. Potato Head (made with *real* potatoes)?

- Slinky, skate keys, 45rpm record adapters, jacks, hula hoops, tiddlywinks, Cracker Jack and Fizzies?

- When milk in glass bottles showed up outside the front door every few mornings?

- Kitchen matches and the metal holder hanging on the wall?

- Meat-grinders, pressure cookers, juicers, waffle irons and gas stoves with trash burners?

- Concrete washtubs in the garage, wood/metal washboards, bar soap, clotheslines and clothespins?

- When "be home by the time the streetlights come on" was the most important house rule?

- In the days before digital clocks, when telling time was the first real thing that you had to learn?

- Wearing one of your father's old dress shirts backward when painting on an easel in kindergarten?

- How cars that had whitewall tires, automatic transmissions and power steering were the most luxurious?

- When Hibernia Bank handed out small tin-can banks for saving coins?

- When kids' cereals always had "Sugar" in the name—Kellogg's Sugar Pops, Sugar Smacks and Sugar-Frosted Flakes; Post's Sugar Crisp and Sugar Krinkles; and Kellogg's and General Mills' Sugar Jets and Sugar Sprinkled Twinkles?

- Making box-stitch lanyard key chains in your school's colors?

- *Romper Room, Ding-Dong School, The Milton Berle Show, I Love Lucy, Candid Camera* and *What's My Line?*

- Captain Kangaroo, Mr. Green Jeans, Bunny Rabbit, Mr. Moose, Magic Drawing Board and Grandfather Clock?

- Tom Terrific and Mighty Manfred the Wonder Dog, Crabby Appleton and Isotope Feaney the Meany?

- Rocky and Bullwinkle, Boris and Natasha, Dudley Do-Right, Mr. Peabody and Sherman?

- Huckleberry Hound, Yogi and Boo-Boo, Augie Doggy and Doggy Daddy, Snagglepuss and Quick Draw McGraw?

- Brother Buzz and Sister Bee, Crusader Rabbit, Winky-Dink and Mighty Mouse?

- Skipper Sedley and Popeye cartoons after school on Channel 4 in the 1950s?

- Mayor Art and his Peanut Gallery after school on Channel 4 in the 1960s?

- Sir Sedley and the Three Stooges after school on Channel 2 in the 1960s?

- Jon Nagy, painting/drawing instructor, on Saturday morning TV in 1962–64?

- Marshall J. with the Dalmatian and puppies on Saturday mornings on Channel 7 in 1965–66?

- Soupy Sales, Emmett Kelly and Bozo the Clown?

- When slingshots, BB guns and Flexi-Flyers were childhood toys that most parents did not like?

- "Art" as the last school day subject every Friday afternoon?

- Duncan yo-yos, plastic water pistols, Tinkertoys, Lincoln Logs, ant farms and View-Masters?

- Public school report cards with only three possible grades: Satisfactory, Fair and Unsatisfactory?

- Catholic school report cards and the "below the line" categories of Deportment/Courtesy/Application?

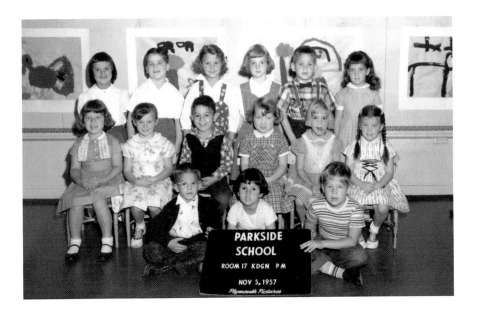

Mrs. Beckerman's afternoon kindergarten class, Room 17, Parkside School, 1957. *Author's collection.*

- "To-morrow is Bank Day"/"To-day is Bank Day" signs in schools?
- Swanson's TV dinners in aluminum trays…and the first time you made one on your own?
- Modern foods: Tang Orange Breakfast Drink, Jiffy Pop popcorn and Rice-A-Roni, the San Francisco treat?
- How Woolworth's at Powell and Market had three lunch counters—two on the main floor and one in the basement?
- When you could pay for lunch, leave the waitress a dime tip and still have change left over from a dollar bill?
- How just across the street was J.C. Penney at 5th and Market—still with elevator operators?
- How a vending machine bottle of Coke, a Hershey bar, a roll of Life Savers or a package of gum was five cents?
- How ice cream cones and comic books were always just ten cents each?
- Racing home from school to catch Captain Satellite at 3:30 p.m. on Channel 2?

- How your family always left Christmas decorations up until Epiphany (Little Christmas) on January 6?

- Clarabelle the Clown's only spoken words on the final broadcast of *The Howdy Doody Show* ("Goodbye, kids")?

- Collecting things: coins, soda bottle caps, matchbooks, TOPPS cards (baseball, Funny Valentines and the Beatles)?

- Jokes and magic tricks: Snake in the Peanut Can, dribble glass, Magic 8 Ball, invisible ink and double-sided coins?

- *Mr. Ed*; *GE College Bowl*; *My Favorite Martian*; *Bonanza*; and *Car 54, Where Are You?*

- The Sunday that we had snow throughout the Bay Area—January 21, 1962?

- Old people watching *The Lawrence Welk Show* on Saturday nights? (Admit it, you've watched it recently on PBS!)

- When Monopoly, Scrabble, Yahtzee, Twister, Mouse Trap and The Game of LIFE were rainy-day activities?

- How typewriters with larger Pica characters that filled up a page were favored over Elite for term papers?

- Wondering what good use typing would ever be once school was over?

- Where you were and what you were doing when you heard that President Kennedy had been shot?

- Long paper chains made from folded-up chewing gum wrappers?

- Your first time at a drive-in movie just over the county line in San Mateo County (too foggy in San Francisco)?

- Finally getting your driver's license and all the promises that you swore to with your parents?

- Eating at the Tick-Tock Drive-in on Ocean Avenue, Doggie Diner, Burke's on Market Street and A&W in Westlake?

- Knowing all about Chinese, Mexican, Italian, Thai, Ethiopian and Indian food by the time of high school?

- Whether or not it was worth it to buy an electric typewriter with an automatic carriage return?

- Calculating costs for the Junior/Senior Prom, and thinking that guys/girls got to pay less than you?

- Finding out how much car insurance rates were for a new driver under age twenty-five?

- Receiving your high school/college diploma and thinking that life's going to be easier from now on?
- Receiving your first paycheck and wondering just who is FICA and why are they getting so much?
- Trying to figure out why people would want to pay for health insurance every month?
- Getting your very first credit card and thinking how convenient it was to pay just a little bit each month?
- *All in the Family, Mork and Mindy, Laverne and Shirley, Happy Days, The Jeffersons* and *Sanford and Son*?
- Learning that landlords really do have the upper hand with security deposits?
- Budget decorating your first place with "drip" candles in old wine bottles?
- Thinking that the gallon bottle of Carlo Rossi Burgundy (stored under the sink) was a great bargain?
- Spaghetti for dinner night after night, even when you had company over?
- Bookcases made of concrete blocks and plywood boards (sometimes with wood-grain contact paper)?
- Getting married, thinking that you had way more in wedding expenses than your spouse?
- Receiving ten fondue pots among your wedding gifts?
- Sometimes getting invited to the weddings of multiple friends in their twenties on the same weekend?
- Turning thirty and realizing that there were a lot of bright people at work who were younger than you?
- Reaching…and watching…and now looking wayyyyyyyy *back* at thirtysomething?
- Realizing that the starter home you once looked at near Ocean Beach is now selling for $1 million?

If you do, then you are in the right place, and you may turn the page and continue reading…

Chapter 1
UNSPOKEN FACTS OF LIFE

Here are a few of the unspoken facts that helped to define things—little truths and truisms from years gone by that everyone in the Western Neighborhoods just seemed to know about instinctively.

- The bread is never fresh on Wednesdays.
- Take the milk from the back (in the days before open dating of dairy products).
- The air raid sirens go off every Tuesday at noon.
- The last Sunday of April is Opening Day for sailing on San Francisco Bay.
- You know the schedule for Sunday summer concerts at Sigmund Stern Grove.
- You know the date for opening day for the Giants' first home game.
- You know when Fleet Week will take place even before hearing the jets swoop past.
- The dividing line between St. Anne Parish and St. Cecilia Parish is Pacheco Street.
- Houses generally cost more in 94116 than in 94122 (with the demarcation line at Ortega Street).
- After World War II, many people came to the Sunset from the Mission District, Western Addition or North Beach.

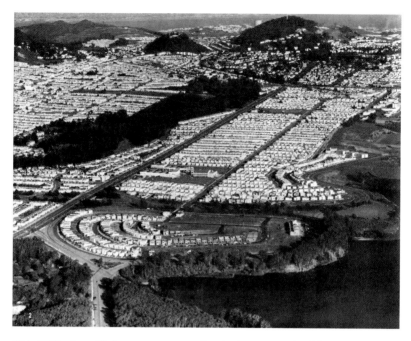

This 1950s view still shows many vacant lots in the area south of Stern Grove.
WNP Collection.

- You can spot a Rousseau-built house half a block away.

- Neighborhood merchants were always closed from Noon to 3:00 p.m. on Good Friday.

- Downtown stores were always open late on Monday nights.

- The bars were always closed until 8:00 p.m. every Election Day.

- Beach Chalet was nothing more than a smoke-filled Veterans of Foreign Wars (VFW) hall with a bar.

- Sutro's, Playland and Fleishhacker Pool were all great people-watching places.

- So was San Francisco Airport on a Sunday afternoon, when many 1950s parents took the kids.

- Herman's Deli on Geary was the best place to go for potato salad.

- Baronial Bakery on Taraval had the best doughnuts in the Sunset.

- Sugar Bowl Bakery on Balboa had the best doughnuts in the Richmond.

- Adeline Bakery on West Portal Avenue had the best Danish pastries in the area.

- Wirth Brothers Bakery on Geary had the best Danish pastries in the Richmond.
- Fantasia Bakery on California Street had the best cakes in the Richmond.
- Golden Brown Bakery on Irving Street had the best cakes in the Sunset.
- QFI at Stonestown had the best meat and produce.
- In the 1970s, 22nd and Taraval Market was a full grocery store with an excellent meat department.
- In the 1980s, 22nd and Taraval Market had become an excellent produce-only market.
- In the 1990s, 22nd and Taraval Market had become a Walgreens, with neither meat nor produce.
- School supplies always came from Woolworth—remember Pee-Chee folders?
- Parents dreaded their child bringing home plastic bags filled with goldfish won at a festival or bazaar.
- Boys' Catholic school uniforms usually came from City of Paris.
- Girls' Catholic school uniforms usually came from Sue Mills on Market Street.
- St. Ignatius (S.I.) guys bought their clothes at Bruce Bary in Stonestown.
- Girls attending Catholic high schools were still shopping at Sue Mills on Market Street.
- In the 1950s, everyone spent time in the summer at Rio Nido, Guerneville or Monte Rio.
- In the 1960s, everyone spent time in the summer at Marin Town & Country Club in Fairfax.
- In the 1970s, everyone spent time in the summer at Konocti in Lake County.
- Well-dressed gentlemen shopped for clothes at Roos-Atkins—three downtown locations plus Stonestown.
- Well-dressed ladies shopped for clothes at Livingston Brothers—downtown and Stonestown.
- In the 1960s, most girls from St. Cecilia School went on to Mercy High School. In 2010, 80 percent of the girls from St. Cecilia went to S.I. or Sacred Heart-Cathedral for high school, and exactly two went to Mercy.
- For years, St. Edward Church on California Street had the latest Sunday Mass in the neighborhood at 4:00 p.m.

- The best place to attend services on the High Holy Days of Rosh Hashanah and Yom Kippur is Temple Emanu-El.

- The best place to attend Midnight Mass at Christmas and Easter is St. Ignatius Church.

- The 2600 block of 18th Avenue was always the best place to see outdoor Christmas lights.

- Most Jewish families celebrated only the first night of Hanukkah, but those with children celebrated all the nights.

- Visiting Democratic politicians always stayed at the Fairmont Hotel.

- Visiting Republican politicians always stayed at the St. Francis Hotel.

- No politicians have stayed at the Palace Hotel since President Harding died there in 1923.

- Until 1965, Democrats took the *Examiner* as a morning paper, and Republicans took the *Chronicle*.

- Before its 1965 demise, many people regarded the evening *News-Call-Bulletin* as little more than a scandal sheet.

- When you can see the Farallones clearly, rain is on the way.

- There used to be numerous gas stations on and near 19th Avenue, West Portal Avenue, Taraval and Noriega.

- The best neighborhood Mexican restaurant in the 1950s and 1960s was the Hot House at Playland.

- The best takeout Mexican food came from Johnson's Tamale Grotto on Vicente.

- The best sit-down Chinese food in the Richmond was Yet Wah on Clement.

- The best Chinese restaurant in the Sunset that offered delivery was Tien-Fu on Noriega.

- The best kosher deli was Gilbert's on Noriega.

- The best Sunset District pizza is still Pirro's on Taraval.

- The best neighborhood movie theatre was the Coronet on Geary.

- There always used to be bars adjacent to long-established undertaking parlors.

- Streetcar lines that offered late-night service were called the "owl" car runs.

- 20th Avenue in the Sunset is wider than most streets because the #17 streetcar line used to run there.

- 30th Avenue in the Sunset is wider than most streets because of a never-built streetcar line there.

- A quarter was routinely called "two bits."

- Men always tipped or touched the brim of their hats when passing in front of a Catholic church.

- The best neighborhood Italian food was always West Portal Joe's or the Gold Mirror on Taraval.

- The best place to spend a day with the kids was the Fleishhacker Zoo, which was free until 1970.

- The best hot meatball sandwich was at Herb's Delicatessen on Taraval every Thursday.

- The best Sunday brunch was at the Cliff House, followed by a walk through Sutro's.

- The best rocky road Easter eggs came from Shaw's on West Portal or Ocean Avenue.

- The best hand-boxed chocolates were from See's—downtown, Clement, Irving, West Portal and Stonestown.

- The best neighborhood ice cream sundaes and Coffee Crunch Cake were at Blum's in Stonestown.

- The best place to see rhododendrons in bloom is Golden Gate Park's Rhododendron Dell, JFK Drive and 8th Avenue.

- The best place to see roses in bloom is the Rose Garden at Park Presidio and Fulton.

- The best place to see tulips in bloom is the Dutch Windmill at Ocean Beach.

- You can buy the Sunday paper on Saturday, but then you miss the updated Sunday obituary section.

- The newspaper sports section is always green, and the Sunday entertainment section is always pink.

- The grocery coupons and the food section are always printed in the Wednesday newspapers.

- In pre-thermostat days, gas furnaces could be set to run at HI, MED or LO and were almost always kept on LO, except from Labor Day to Thanksgiving, when they were usually OFF.

- Hibernia Bank was nicknamed the "Irish warehouse" because of so many Irish employees and customers.

- Hibernia Bank's onetime branch at 22nd and Noriega will forever be known as the "Patty Hearst branch" since the April 15, 1974 robbery by the Symbionese Liberation Army.

- Every Italian family had at least one member who "worked with A.P. Giannini" when Bank of America was still Bank of Italy (1904–29).

- Many Jewish San Franciscans sent their Christian neighbors all leavened products in the house before Passover.

- Many Christian San Franciscans returned the favor by sending their Jewish neighbors the overload of chocolate candy in the days following Easter.

- Larraburu in the Richmond District made the best French bread.

- Most neighborhood bakeries featured hot cross buns for Ash Wednesday and Lent.

- Star Bakery on Church Street was the best place to buy Irish soda bread for St. Patrick's Day.

- Ukraine Bakery on McAllister Street was the best place to buy challah.

- Liguria Bakery at Stockton and Filbert is still the best place to buy real focaccia.

- Walgreens, now on just about every street corner, had its first big San Francisco store in Stonestown in 1952.

- Williams-Sonoma was a single, tiny downtown store on Sutter Street that sold imported kitchenware.

- The first GAP was on Ocean Avenue near the El Rey Theater in 1969. ("Fall into the GAP!")

- Emporium's second store was in Stonestown, which opened in 1952 and had the telephone number SEabright 1-2222, while the original downtown store was Yukon 2-1111.

- El Sombrero at 22nd and Geary was the best "dress-up" Mexican restaurant in the 1960s and 1970s.

- Le Cyrano on Geary near 6th Avenue was the best French restaurant in the 1970s.

- The Red Chimney was a popular local restaurant adjacent to the Emporium at Stonestown.

- The Red Roof, with branches on California Street and on Ocean Avenue, was a completely different business, owned by attorney-politician Harold Dobbs, who also founded the iconic Mel's Drive-In.

- Zim's ("Zim's—Where Else?") had the best broiled hamburgers and thick milkshakes from 1948 to 1995 (more than a dozen San Francisco locations and even more throughout the Bay Area during its peak years).

- Neighbors always sent platters of food, casseroles or cakes (rather than flowers) when someone died.

- New Year's Day is often clear and sunny.

- Fourth of July is always cold and foggy.

- Halloween is usually damp and drizzly.

- Never try to drive north on 19th Avenue on Thanksgiving Day afternoon, or you will be stuck in traffic.

- Irish families always celebrate Easter with ham for dinner.

- Italian families always celebrate Easter with lamb.

- Greek families always celebrate Orthodox Easter with goat.

- Easter was not complete without a visit and photo with the Easter Bunny at the Emporium, plus a look at the baby chicks that were due to hatch in incubators in the last few days before Easter.

- Banks were open only from 10:00 a.m. to 3:00 p.m. Monday through Thursday and until 6:00 p.m. on Friday.

- Entrances to apartment towers at Stonestown and Parkmerced were never locked until the mid-1970s.

- Kids checked the coin return slot on every pay phone for overlooked dimes.

- "Save your pennies for the parking meter."

- There was always a place to park your car near your destination.

- A streetcar or bus ride was always cheap and reliable, so very few people bothered to drive downtown.

- Street sweeping was something that fastidious retired people did daily in front of their own homes.

- Borden's delivered most of the milk in the Sunset District in the 1950s.

- Sun Valley Dairy on Irving Street was the best place to buy strawberry milk in glass bottles.

- Maison Gourmet inside the QFI Market at Stonestown sold "Pizza Pups"—a slice of cheese pizza wrapped around an all-beef hot dog—for twenty-nine cents each back in the early 1960s.

- In deference to local florists, newspapers would never use the phrase "no flowers" in paid obituaries, opting instead for "donations to your favorite charity preferred."

- On Saturday afternoons, you could always bump into a neighbor in Sears at Geary and Masonic.

- As late as the 1960s, many neighborhood pharmacies still delivered prescriptions at no extra charge.

- Notre Dame (French pronunciation) was a downtown church and school.

- Notre Dame (American pronunciation) was a hospital (now senior housing) and a Mission District high school.

- People who live anywhere south of San Francisco were said to be "down the Peninsula."

- People who live anywhere east of San Francisco were said to be "across the Bay."

- People who live anywhere north of San Francisco (from Sausalito to Canada) were said to be "up north."

- Any location between Bakersfield and Mexico was described as "down in L.A."

- "Knotty pine" always described a basement room and was usually accompanied by the phrase "and ½ bath."

- Neighborhood libraries were usually open weekdays from 9:00 a.m. to 9:00 p.m., as well as from 9:00 a.m. to 6:00 p.m. on Saturdays.

- In spite of the distance, St. Rose Academy remained popular with Sunset District girls until it closed in 1990.

- Roberts-at-the-Beach was a popular party/wedding reception destination until the late 1960s.

- Depending on where you are, north or south of Golden Gate Park, you know the quickest route to the other side.

- In the 1950s, San Francisco College for Women (aka Lone Mountain, which became its official name in 1970) was sometimes referred to among some Catholic families as "San Francisco College for Lonely Women."

- The park was always Golden Gate.

- The zoo was always Fleishhacker.

- The tunnel was always Twin Peaks.

- The boulevard was always Sunset.

- The beach was always Ocean.

- The weather was usually foggy.

The place was called HOME.

Chapter 2

HOME IS WHERE YOUR STORY BEGINS

My parents were married in August 1947 and bought their one and only house on 18ᵗʰ Avenue near Vicente just a year later, on their one-year anniversary—a decision that helped to form the basis for meeting many of the people who have played major roles in my life.

Our house had been built in January 1936 (according to the electrical permit posted in the garage) for a Mr. and Mrs. Galleazi, whose family manufactured accordions. According to one of the neighbors, all of these original homes sold for about the same price, $6,500, in 1936. By the time my parents became the second owners in 1948, the price had exactly doubled to $13,000. Then, as well as now, living in San Francisco was not cheap.

The standard home back then—either house or apartment—was almost always two bedrooms. Relatively few homes in the Western Neighborhoods had the coveted third bedroom on the main floor. What were the builders thinking? Nobody was going to have children of opposite sexes? Or that no one with children would ever be buying a home? Likewise, builders never planned for changing automobile styles, and most people eventually had to replace those original double garage doors with an overhead door, thus widening the opening to allow for the newer cars. This was a big issue around 1960, when cars began sprouting tail fins. Electric openers began appearing in the 1970s and 1980s, as the neighborhood population began aging a bit.

Growing up, I had some friends and classmates who lived in apartments—mostly in the vast Parkmerced and Stonestown apartment

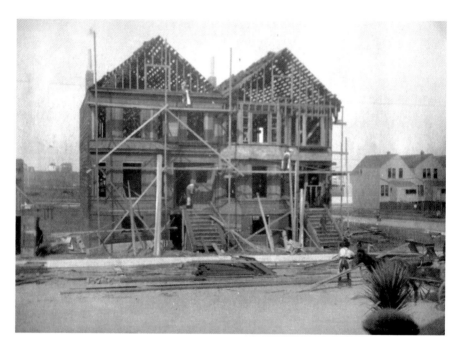

The Richmond District was settled prior to the Sunset District. Here, two houses are under construction on 2nd Avenue at Balboa, circa 1900. *Paul Trimble Collection.*

complexes, adjacent to 19th Avenue and south of Sloat Boulevard, and some in classic older buildings that have since gone condo for unbelievable prices. Those apartments were the longtime homes to thousands of San Franciscans. In terms of furnishings, they were almost identical during that era to the rowhouses that covered the sand dunes throughout the Richmond and the Sunset.

Our home's builder constructed similar houses along the entire east side of 18th Avenue, from Vicente to Wawona, as well as along the west side of 18th from Vicente only halfway up the block (the remaining homes were built around 1939–40 by a different company). In trying to keep the prices consistent, the original homes were designed with three slight differences. The first group, from the corner of Vicente halfway up the east side of the block, had large kitchens, medium-size dining rooms and a breakfast room but no view. Those on the west side, from the corner of Vicente halfway up the block, had medium-size kitchens, bigger dining rooms and a breakfast room, plus a view of the ocean from the bedrooms. The final group had large, eat-in kitchens, with medium-size dining rooms and no breakfast room

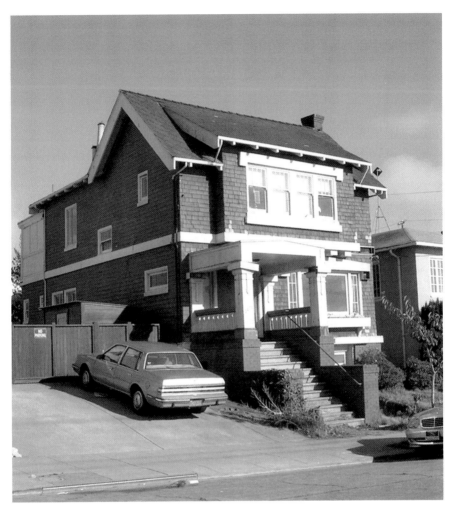

This home at 20th and Ulloa was built in the early years of the #17 streetcar line (1916–45) and occupied by members of the same family until the end of the millennium. *Woody LaBounty photo.*

but a spectacular westward view from the living rooms. All were an easy walk to St. Cecilia Church and School at the corner.

In my early days, every house had the requisite wooden kitchen table and chairs that morphed into Formica-topped tables and chrome-legged chairs in the mid-1950s and then into maple hardwood table-and-chair sets by the 1970s. Everyone seemed to have the same yellow-green-red-blue set of Pyrex bowls, a Sunbeam Mixmaster and Revere copper-clad pots and pans. Appliances were always white, although many households embraced the classic

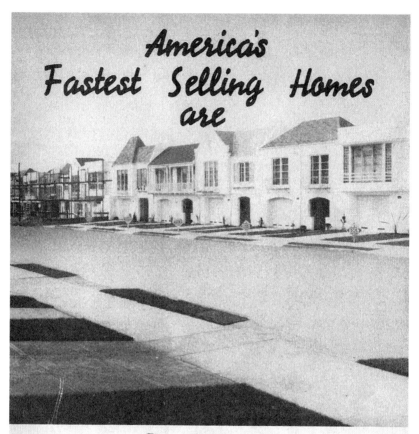

The undisputed king of residential building in San Francisco in the 1930s, Doelger later moved south to build Westlake in Daly City. *Courtesy of Prelinger Library.*

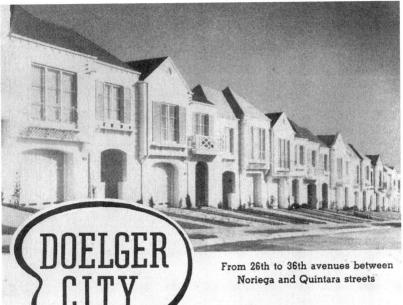

DOELGER CITY

From 26th to 36th avenues between Noriega and Quintara streets

Pictured is a striking group of homes, representative of others being completed each day by Henry Doelger. They are the outgrowth of a boyhood dream that one day the desolate sand dunes of the Sunset might be replaced by trim modern homes, owned by "Mr. and Mrs. Average San Franciscan," and that he would have a part in this vast undertaking.

A drive throughout the Sunset District illustrates what his 15 years of home building have meant. These 2,500 Doelger homes are not only a remarkable development, but one of the most modern communities in the entire United States, which has been given the unofficial title, "Doelger City," by its proud residents.

You will find the people living in this "city within a city" friendly folks in the average income group, for that, too, has been a Doelger goal: to build *moderate* priced homes for *moderate* income families,

Today you will find, besides homes, that schools, churches, shops, and markets also have come to Doelger City. And each week brings the beginning of additional blocks of convenient, modern homes. Truly, this is where *real living* is being enjoyed—real living that can so easily be yours!

Start today on the road to financial independence by owning a DOELGER home homes that are built to last!

Doelger aimed to meet the needs of average-income households. In a supreme bit of irony, many of these homes are now priced near $1 million each. *Courtesy of Prelinger Library.*

1970s Harvest Gold or Avocado in later years when the San Francisco firm of Mayta-Jensen swept through the neighborhood in a series of kitchen updates (end of those built-in, pull-down ironing boards). These kitchen renovations always managed to add a lot more counter space and electrical outlets—our original kitchen had only one outlet behind the stove and one other adjacent to the ironing board.

All the kitchens on our block had a skylight, but during those remodels, most people had a light fixture installed within the skylight to brighten things up a bit at night. Our original refrigerator was huge for its time—a white 1948 Hotpoint with twelve cubic feet total and a freezer section that could hold four trays of ice and a few boxes of frozen vegetables, maximum. I still have the original instruction booklet, showing smiling whole fruits and vegetables dancing a conga line of sorts in and out of the two crisper drawers. A half-gallon of ice cream would have taken up virtually the entire freezer unit, and therefore such treats were only purchased in small quantities and brought home for immediate consumption. Our kitchen dishes in the 1950s were white, with a branch and pine cones on them, to be replaced in the late 1960s with unbreakable Corelle with tiny little flowers around the border and then in the 1970s with the classic Franciscan pattern Desert Rose.

Most homes had a corner fireplace in the living room, and many families never used their fireplaces, wanting to keep their homes "clean." Some rationalized that with a central gas furnace, there was no need to rely on a fireplace for heat, so why go to all the bother of lugging wood upstairs? In retrospect, this appears to have been a female argument. More than one husband of the 1950s is reported to have said to his beloved, "Ya know, the day we get home from the cemetery after your funeral, the first thing I'm gonna do is light a fire in that fireplace!"

Many of the living rooms had cathedral ceilings, some embellished with Philippine mahogany beams to match the wood molding and doors in the living, dining and entry areas. Again, to equalize the costs of all the homes, the builder sometimes eliminated the beams or dropped the living room ceiling a bit, though still leaving it vaulted, with or without plaster embellishments. Electric wall sconces were a standard source of light in the living rooms, and most dining rooms started with wrought-iron chandeliers that gradually morphed themselves into crystal chandeliers as time went on.

Almost without exception, these homes had a downstairs room, complete with a sink and bar setup. These eventually became rainy-day play locations for all of the kids who came along in the 1950s and were the locales of most of our childhood birthday parties. Dad's friend Bill had an amazing setup of

glassware arranged on glass shelving with recessed lighting behind the bar of his knotty-pine paneled room (complete with gold-color "comedy" and "tragedy" masks hanging above that I still remember to this day). Eventually, many firstborn sons eventually commandeered these spaces as bedrooms sometime during their high school years.

The center patio was a standard feature of those homes, although as time went on, most people noticed the heat loss—or discovered that the patio floor was beginning to leak—and covered the whole thing over with a vented skylight. Many people filled these areas with a variety of flora and fauna. In about 1961 or so, there was a big neighborhood push for fuchsias, which can thrive in cool, foggy weather. Mrs. Cauley had an enormous variety in her patio and often rooted them for the neighbors. When given some attention, the plants produced steady streams of color, although there was a certain amount of maintenance involved, including daily watering (multiple times during warm weather), plus fertilizing, picking up fallen blooms and chasing the ever-present bee population out of the house.

Many of the adjacent dining rooms had built-in cabinets to store the china and crystal that moms had all collected upon marriage, and tables were lovingly set for all the christenings, birthdays, Thanksgivings, Christmases and the buffet gatherings that always followed family funerals. Moms always took their places at the table in chairs that were closest to the swinging kitchen door, with dads holding down the opposite ends. Kids, grandparents, aunts and uncles all had their usual spots—assigned seating, so to speak—and no one ever had to wonder where they were supposed to sit. Moms always had it planned out well in advance, and one look from them would tell a guest exactly where to sit.

Unlike Ward and June Cleaver, my parents never served regular weeknight dinners in the dining room—it was for special occasions only. In the 1950s, it was a real treat for kids to be allowed to have dinner on the coffee table in front of the TV in the living room, while the parents could then relax in the kitchen. While this was probably not the best for developing conversational skills in some, it did give the parents a brief respite before the turmoil of bathtime and bedtime.

The bathrooms on our block were all classic Art Deco, in various combinations of pink, yellow, peach, pale green or powder blue tiles with black accents. Some of the houses had "split" baths, with the toilet in a separate room that had access from the hallway and from the main bathroom. The sinks were the classic pedestal design, and there were separate stall showers, originally with shower curtains; later, many people updated those to include

glass shower doors, with the requisite frosted swan, after an advertising blitz by the old Sears, Roebuck Co. at Geary and Masonic.

Most of these bathrooms never had an electrical outlet, unless the owners had one installed in the years after construction. Presumably everyone towel-dried their hair, and men shaved their faces and women their legs with a blade in those early days. Every house had exactly one bathroom, although some lucky folks had the "half-bath," often just a toilet, tucked away in the garage near the downstairs room and its bar—presumably the builder knew the physiological effects of beer on the human body over time. It continues to amaze me how families with two adults and three or more kids could cope with just a single bathroom. Three kids seemed to be the demarcation line—at that point, many families added an extra bathroom downstairs, much to relief of everyone's kidneys.

The original phone was in a recessed shelf in the hallway, complete with a telephone book holder beneath the shelf. These were obviously designed for the old candlestick-style phones of the early 1930s, with the ringer located in a recessed, lattice-covered area above the shelf. By the time I arrived on the scene in 1951, the phone, with its twelve-foot cord, was an updated model that looked like a late 1930s prop from *The Maltese Falcon*. This remained until the late 1960s, when it became modern and beige and sported a fifty-foot cord that could be dragged all over the house. I can only imagine just how many of us were tripped up by those cords being stretched across the hall and into the bathroom when we desired privacy for a conversation.

When it came to phones, we always had a party line in the 1950s and early 1960s. Mr. and Mrs. Vincent, who lived next door to us, and Mr. Nielsen across the street were on our party line all those years. Sometimes you would pick up the phone and hear that a party line neighbor was using it, and you would then hang up quietly and wait for them to be done; however, the phone rang only in the house that was being called. Calling a party line neighbor was also a bit tricky—you had to go through the operator for that.

By the 1980s, iron gates had become a standard feature on most homes in the neighborhood, a factor that has been universally recognized as the beginning of a decline in the overall quality of life for the neighborhood. The fact is that the 1980s era corresponded with the passing of many of the men in the neighborhood. Many of the moms, with kids grown and moved away, plus a recently deceased spouse, felt a far greater sense of security in their longtime homes with those iron gates in place.

We had many original neighbors for years. Our uphill neighbor died in 1982, but one of his adult children continues to live there, and our downhill neighbor lived there from 1936 until his passing in 1991. This was par for the course for that block—even today, there are still multiple houses there that are occupied by the children, grandchildren and even great-grandchildren of the original owners, due in some part to family ties but also due to the intricacies of Proposition 13 and subsequent laws involving real estate transfers among family members.

In spite of all the physical elements that surrounded us, what remains first and foremost in my memory are the people who came and went in the nearly fifty-five years that our family occupied that 25- by 120-foot spot of San Francisco. I can still see images, either in photos or in my mind's eye, of excited thirtysomethings bringing me home from the hospital in 1951; Mom in her navy blue polka dot dress, along with a hat and gloves; and Dad in a light-gray suit standing next to her in front of the dark green 1950 Plymouth. My christening party, a few weeks later, was the biggest gathering that they had hosted in the house up until then.

I can still remember long-gone grandparents, aunts, uncles, cousins, schoolmates and prom dates who joined us for birthdays, First Communions, Confirmations, graduations, school dances and all sorts of other events, as well as all the hugs and kisses that were exchanged at the front door as they arrived and left. Pictures were always taken of everyone around the dining room table and again posing in front of the fireplace. Looking back, it's amazing that there were practically no changes to that fireplace/mantel backdrop in more than fifty years—glass-domed anniversary clock in the middle, with a few family photos on either side, and a Dutch boy figurine on the left, with the matching girl figurine on the right (the first things my parents bought for their new house in 1948, from Hamill's Hardware Store on Taraval). The potted plant in the corner, sometimes real and sometimes fake, varied occasionally.

There was the St. Patrick's Day in 1956 when Mom and Dad hosted an engagement party for Dad's brother and his new fiancée, and Mom wowed everyone by placing a tiny drop of green food coloring in the bottom of each champagne glass—a project in which I was allowed to help out.

Thanksgiving had its own set of rituals. Although we always went to Mom's mother or her sister's for Thanksgiving—Mom never hosted her own until 1992—there was always a turkey in the oven "so we can have enough leftovers." Were we the only family who cooked a whole turkey just to have leftover turkey and dressing for sandwiches after the holiday? I think not.

Christmas, particularly on our stretch of 18th Avenue, took on a life of its own. The "night of the lighting" was usually the Saturday night two full weeks before Christmas, when Santa arrived on the fire engine and all the Christmas trees and outside lights were turned on. Everyone hosted an open house that night, with large quantities of Chex mix, Lipton's Onion Dip and Christmas cookies, consumed and washed down with a variety of beverages. My parents always seemed to favor white trees, both flocked real ones and artificial, although in 1959 we had one of those trendy aluminum trees. For the last twenty-five years of her life, Mom was committed to green trees, both real and artificial, with small clear lights and gold ball ornaments.

Our longtime family friend Theresa invariably dropped by in the middle of Dad's pre–Fourth of July birthday dinner, with her ever-present box of See's candy for him. Originally one of Grandma's friends, she continued her ritual long after Dad died in 1980, a silent little reminder of a family friendship that went back to 1906, when my great-grandparents left their burned-out home South-of-Market and became next-door neighbors and close friends with Theresa's parents in the Mission District.

I remember my high school and college graduations from S.I. and University of San Francisco (USF), as well as what had to be the two largest and longest parties that we ever held in that house—both starting in the late afternoon, topping sixty people each and spilling out, upstairs, downstairs and into the big backyard, with the final guests departing in the wee small hours of the next morning. A good time, as they say, was had by all.

Easter brunches were one of Mom's favorite get-togethers in later years, as we mixed and matched family and friends, older-middle-younger generations, co-workers and neighbors. The early morning buffet morphed itself into an all-day snacking session, and the leftover ham became dinner for anyone still there.

In Mom's final years, approaching age ninety, she remained at home more and more, save for that standing hairdresser appointment just down Vicente Street that she faithfully kept on Thursdays, almost up to the very end. Seated in her "den"—almost all the women who lived alone converted the second bedroom into a den with a couple of easy chairs and a console television, televisions having been banished from most of the living rooms on that block sometime in the 1970s—she continued to have visitors in person and by telephone daily. Assisted by a wonderful Irish woman, who had been helping her out a few hours each day for ten years, Mom was surrounded by everything she wanted—telephone, TV remote control, a copy of *TV Guide*, her personal telephone book, a pitcher of ice water, a pack of graham

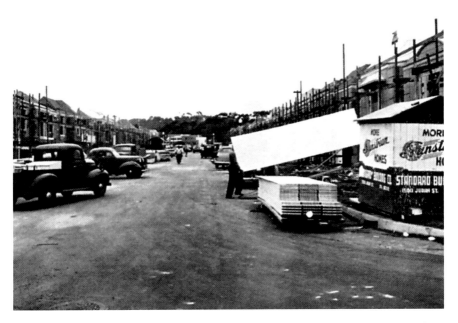

Sunstream Homes built homes in Lakeshore Park south of Sloat Boulevard in the years just before and just after World War II. *WNP Collection.*

crackers for snacking, an emery board, hand lotion, Kleenex, family photos and a number of other small items that made her chair the most comfortable and convenient spot in the whole house.

As I drive up and down that block today, I still see the manicured patches of lawn, the present generation of children, still running in and out of one another's houses, plus dads in shirtsleeves and one or two moms in aprons, chatting casually with one another. The Venetian blinds in the living room windows still twitch, almost imperceptibly, as neighbors peer out to see just who is driving along so slowly and staring at things. It's as though a popular, long-running play is still in progress, being acted out on the same stage and under the same lighting, with just a few minor changes in the cast of characters.

Chapter 3

DAD AND BILL'S NIGHT OUT

Every time I find myself driving northbound on Interstate 280 and exiting onto Junipero Serra Boulevard, on the way into San Francisco, I think of my father and our neighbor Bill and bless them for something that they did back in 1955.

At the time, both the State of California and the San Francisco Board of Supervisors (mostly a bunch of older Irish males back then, but just as cantankerous, divisive and argumentative as those boards that have come

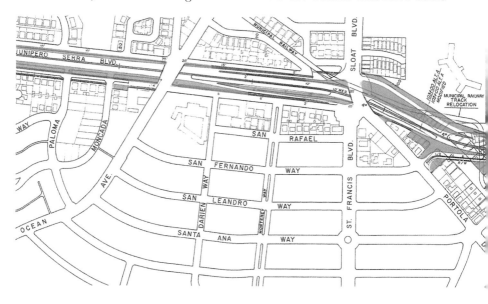

after them) decreed that a massive freeway plan was necessary to keep San Francisco traffic moving. One part of that plan was a monstrosity called the Western Freeway, envisioned by its designers as an essentially straight line from San Francisco International Airport to the Golden Gate Bridge. The original San Francisco Planning Department Freeway Plan of 1948 had morphed itself into a slightly altered version by 1951 and, finally, into something known as the 1955 Trafficways Plan, thus setting the stage for what was to come.

A map of the plans shows in horrific clarity a northward continuation of an eight-lane-wide freeway from the 19th Avenue exit from Interstate 280, superimposing itself and obliterating the present Junipero Serra Boulevard, with overcrossings at Winston Drive, Ocean Avenue and Sloat Boulevard.

The plan then became even more destructive, calling for the demolition of virtually all homes and businesses in an area roughly bounded by 14th Avenue, Sloat Boulevard and West Portal, along with some Portola Drive houses, before moving in a straight line and removing about two hundred homes on the west side of 14th Avenue and the east side of 15th Avenue from Wawona, all the way north, four blocks to Santiago Street.

At Santiago, between 14th Avenue and 15th Avenue, this eight-lane-wide serpent would have plunged underground into a tunnel—snaking beneath Rivera, Funston, 12th, Quintara, Cragmont, 10th, Pacheco, 9th, 8th and Ortega—before reemerging as a surface freeway just north of Laguna Honda Boulevard and MUNI's Forest Hill Station.

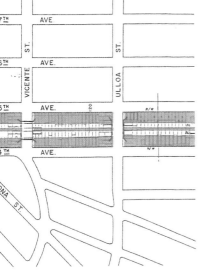

From that point, the freeway was to have continued north, resurfacing as a sort of Loch Ness monster and devouring even more homes and businesses in the inner Sunset, entering Golden Gate Park at about 9th Avenue and obliterating the future site of the Hall of Flowers before veering west. Like a destructive tornado, it would have cut a path through the park, tearing through the Rose Garden before finally exiting at Fulton Street. From

If built, the Western Freeway would have destroyed thousands of home and businesses in the Parkside District. *Courtesy of Eric Fischer.*

that point, it would have connected with Park Presidio Boulevard, whose tree-lined path was slated to have been torn out and converted to freeway status, with a few east–west overpasses. This final surface section would have resulted in an additional loss of homes and businesses, bulldozing its way through the Richmond District, all the way to the Golden Gate Bridge toll plaza—not a pretty sight at all.

"For Sale" signs began to sprout like weeds throughout the neighborhood. It was the beginning of big city flight to the suburbs. More than a few of our neighbors sold and headed south to Westlake, San Bruno or Millbrae. The public outcry grew louder, with headlines speculating, "San Franciscans to Be Forced Out of Homes."

My folks, along with most of their neighbors, were far more than casual observers—they were parents, proud homeowners of just a few years, with a mortgage and a primary financial asset that sat smack in the middle of the freeway's path. Their church, St. Cecilia, then under construction, would also have been severely affected by the planned Western Freeway through the adjacent blocks, virtually splitting the parish in two. St. Cecilia's pastor, Monsignor Harold E. Collins, no less a shrewd Irish politician than any of his lay counterparts on the board of supervisors or in Sacramento, declared war on the freeway and rallied his troops.

My Dad and Bill were a couple of ordinary San Francisco guys who moved to the Sunset District with their widowed mothers before World War II—Bill living on 25th Avenue near Ulloa and Dad on 21st Avenue near Rivera. They were GIs who had come home in 1946, married their sweethearts and started raising their families. By 1955, they were in their early forties, living across the street from each other, and their idea of relaxation at the end of a long day was sitting at home in a comfortable armchair after dinner with the evening newspaper, watching John Cameron Swayze on their new RCA television sets.

Heeding Monsignor Collins's battle cry, Dad and Bill, along with several hundred other men and women in the neighborhood, got up from their chairs and marched off to Lincoln High School one cold, dark night in December 1955 to attend a public meeting on what was being proposed. The turnout was enormous, and the angry crowd was unanimous in opposing the freeway plan. The politicians were stunned. Seldom did the public rise up like this, and civic leaders were eventually forced to acknowledge that the Trafficways Plan might not be built as originally envisioned.

The protestors argued that the prospect of this quiet area being torn apart was unimaginable. Then, as now, there were family connections throughout

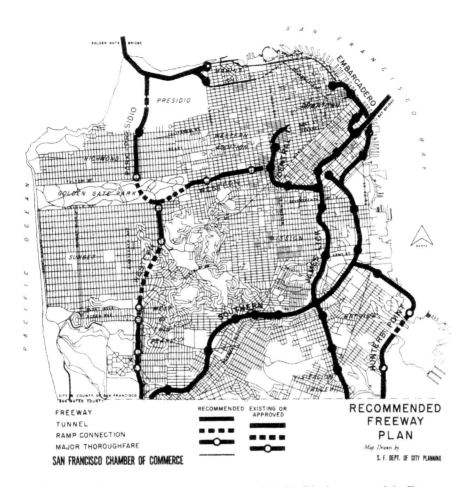

The State of California's freeway plan through the Parkside District prompted the Freeway Revolt of the 1950s. *Courtesy of Eric Fischer.*

the individual neighborhoods that would have been sorely affected, as most residents had friends and relations living nearby. Shopping at Stonestown, on Taraval or on West Portal Avenue and then returning home would have involved crisscrossing a massive, curving freeway structure multiple times. Getting small children to and from the area's many elementary schools— such as St. Cecilia, St. Anne, West Portal Elementary, Parkside, Commodore Sloat and the new Herbert Hoover Junior High School—would have been a logistical nightmare. The peace and quiet of the entire west side of San Francisco would have been shattered, along with the daily lives of tens of thousands of residents.

Opened in 1940, Lincoln High School was the site of a public meeting in 1955 that eventually resulted in an end to freeway construction in San Francisco. *Woody LaBounty photo.*

Miraculously, the public outcry was heard. Alternatives were eventually proposed and rejected, but people like Dad and Bill, and hundreds of their other friends and neighbors, kept the pressure on the politicians, long and hard. It was a topic that remained on the minds of residents day after day, year in and year out, for almost four years.

Given their own timetable, it took the San Francisco Board of Supervisors until 1959 to cast the official vote that put all future freeway construction within San Francisco on hold. The "Freeway Revolt" had scored a big win in the board's fateful decision. A collective sigh of relief went up from the Western Neighborhoods, and the Trafficways maps and plans for a Western Freeway were tucked away into the silence of oblivion. It was no coincidence that property values rose instantly, and they shot up more than thirtyfold in the next half century.

Today, we sometimes creep along 19th Avenue and Park Presidio, to and from the Golden Gate Bridge, slowed by the traffic. At times like this, we need to take a look around at all the tidy stucco houses and flats covering the landscape, plus the small, special businesses that so many of us favor, and realize that this landscape was preserved for us by ordinary residents—men and women who attended that December 1955 meeting at Lincoln High School and expressed their collective outrage to the politicians nearly sixty years ago. For all of us who lived in the area then, for all who came after us and for all those future residents who may call the area home, it remains a welcoming and hospitable place, thanks to people like Dad and Bill (who, sadly, have been gone since 1980 and 1967, respectively)—a couple of ordinary guys who decided to get up out of their comfortable armchairs so long ago to spend one night out.

Chapter 4

MUNI, A LOVE/HATE RELATIONSHIP

For most residents, MUNI (the San Francisco Municipal Railway) represents a deeply personal love-hate relationship. From its very first run along Geary in December 1912, MUNI has had countless delays, breakdowns and other assorted troubles, sometimes reminiscent of slapstick comedy. Yet one simple fact remains: we couldn't live without it.

MUNI competed at one time with the Market Street Railway franchise, and there were four sets of streetcar tracks on Market Street, fanning out to residential districts. While MUNI operated the lettered streetcar lines, MSR operated the numbered lines, including the well-used #17 line, which began downtown and then came west and meandered around Golden Gate Park before the tracks turned and then ran north–south on 20th Avenue, from Lincoln Way to Wawona, crossing the path of the N-Judah and the L-Taraval. Many parts of the city also had crisscrossing MUNI and MSR lines.

Perhaps it was luck, perhaps it was the competition or perhaps it was just the fact that the 1930s were the heyday of public transit in this country that made MUNI so successful back then. Many San Franciscans did not drive before World War II, and even in those households where there was a licensed driver, there was often no motor vehicle. Public transit won by default.

After the 1944 merger with the Market Street Railway was approved by San Francisco voters, MUNI was the only game in town (save for the California Street Cable Cars system, which remained a separate company until its 1952 merger with MUNI). The residents of San Francisco now owned the city's public transit system, but much of the rolling stock was in a

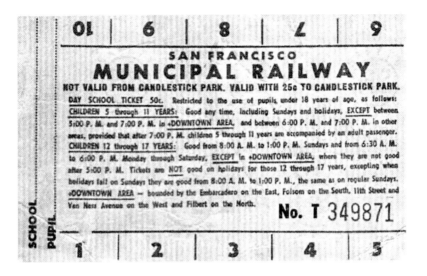

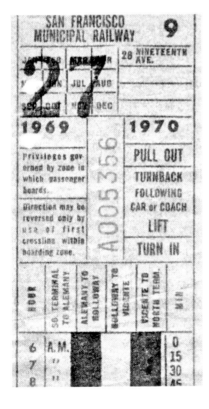

Above: MUNI student car tickets, sold for fifty cents each, were good for ten MUNI rides—a week's worth of transportation to and from school in the 1960s. *Jo Anne Quinn Collection.*

Left: MUNI transfer from the 28-19th Avenue line on one of the author's last rides to S.I. on Stanyan Street in May 1969. *Author's collection.*

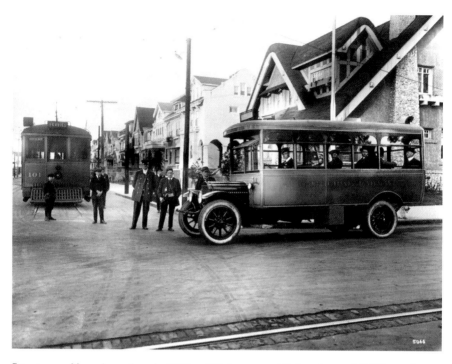

Streetcar and bus, shown here in 1917 at 10th Avenue and Fulton, long a MUNI transfer point. *WNP Collection.*

sorry state after decades of neglect by officials of the Market Street railway through the Depression and World War II years.

In the postwar era, MUNI officials began replacing most of the city's streetcar lines with motorbuses and electric "trackless trolleys." Only five streetcar lines (J, K, L, M and N) survived because of their unique routes—through Mission District backyards and via the Twin Peaks and Duboce (Sunset) Tunnels. Even MUNI's original B-line streetcar, from Market and Geary and all the way to Sutro's at Ocean Beach, had its tracks torn out after a December 1956 conversion to diesel buses.

By the 1960s, MUNI officials had aligned themselves with the BART Board of Directors and engaged in building a massive subway project under Market Street—something that had been under consideration off and on for more than half a century. (BART's exclusive right-of-way also disrupted MUNI operations in the Mission District for roughly the same period.) From the mid-1960s through the early 1970s, Market Street was a war zone, with daily disruptions that affected transit, vehicles, pedestrians

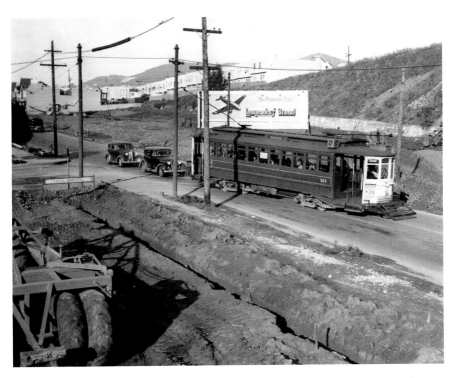

Streetcar on the #17 line turning onto 19th Avenue at Wawona, December 1937. At the time of this photo, 19th Avenue was being widened to accommodate more north–south vehicle traffic to and from the newly opened Golden Gate Bridge, a project that took several years to complete. *Jack Tillmany Collection.*

and merchants. Tracks were rerouted frequently to accommodate ever-changing conditions at the construction sites of stations at Montgomery, Powell, Civic Center, Van Ness, Church and Castro. Even the normally quiet West Portal Avenue was a busy construction site for years, as the 1917 façade of the Twin Peaks Tunnel was demolished and rebuilt as MUNI's West Portal Station.

Beginning in 1969, there was a massive effort to replace the aging bus fleet, and San Franciscans soon saw a new livery of maroon/gold replacing the decades-old green/cream fleet of buses. MUNI later suffered a severe shortage of diesel buses in 1981–82 when the 1969-era stock began reaching the end of its useful life. Old buses were purchased from other municipalities, often with only a MUNI logo painted on the front and sides before being placed into revenue service. Also, beginning in 1982, the cable car system was shut down for twenty-one months of rebuilding.

By the early 1980s, and the introduction of the Boeing-built cars on the MUNI Metro lines, the transit system's color scheme had become orange/white. For a variety of reasons too complex to analyze here, MUNI's reliability factor began to decline at the same time that costs began to rise. Passengers were soon beginning to pay more and more of the system's total operating costs, as subsidies decreased.

Population shifts in the city and introduction of Metro service also began to cause issues with service levels. Increasing population density in the Inner Sunset often resulted in downtown-bound N-Judah streetcars becoming packed on weekday mornings, long before the cars entered the Sunset (Duboce) tunnel at Cole and Carl, leaving angry crowds of waiting passengers. Service in the Twin Peaks Tunnel, even after a massive track rebuilding program, could sometimes be sporadic, and this author often found himself and thousands of others walking through a darkened tunnel from an inoperative streetcar to Castro, Forest Hill or West Portal station. Likewise, Richmond District riders, particularly on the 38-Geary line, found themselves victims of severe overcrowding, even with Express and Limited Stop buses added to the route. The beloved notion of a MUNI-only subway from downtown to the Richmond, envisioned by some after Marin County's withdrawal from BART, proved to be impractical and was eventually abandoned.

By the 1990s, Breda-built streetcars in a red/silver livery were replacing the Boeing vehicles. These cars proved extremely noisy, and according to published reports, it cost the city significant amounts per car to remedy this issue. In addition, due to questions about braking capabilities, there was an order to reduce running speeds from the original fifty miles per hour in the subway. By 1996, equipment and management issues were prompting action by an organized group of passengers that became highly vocal in 1998, when MUNI suffered severe problems as the Metro system was converted to automated train control. Finally, in 1999, voters approved the formation of the San Francisco Municipal Transportation Agency (SFMTA), ultimately leading to improved service standards.

In December 2009, the SFMTA ordered changes to more than 60 percent of MUNI lines in an effort intended to both control cost and improve on-time service. These changes were the most significant in more than thirty years.

Issues with construction projects and the unreliability of the new cars were eventually resolved, but then new concerns arose about passenger behavior. The problem of homelessness eventually found its way from the streets onto MUNI vehicles, resulting in passenger complaints. Other issues,

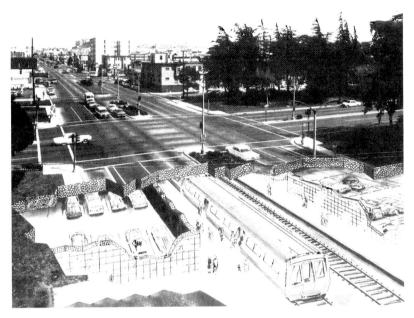

The unfulfilled dream of a MUNI underground streetcar system between downtown and the Richmond District, late 1960s. *Courtesy of Eric Fischer.*

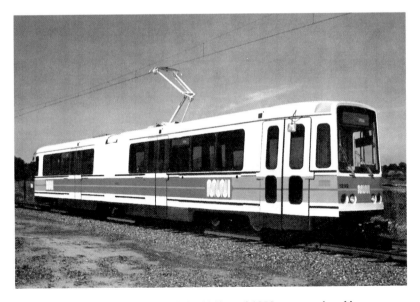

The green-and-cream streetcars of the 1940s and 1950s were replaced by orange-striped Boeing-made cars in 1980 when the Metro subway opened. By the late 1990s, these had been replaced by silver-red Breda-made cars, and bids are now being sought for a brand-new fleet. *Author's collection.*

such as passengers transporting live poultry and the like—whether real or apocryphal—are often cited, along with constantly rising fares. From a $0.15 general fare for most of the 1950s and 1960s (still only $0.25 by the early 1980s), the cost for a single adult-fare MUNI ride is now $2.00 (increasing again to $2.25 on September 1, 2014) and a whopping $6.00 for cable cars. Getting around San Francisco now represents a considerable expense to most residents.

Extensions of streetcar lines to serve new South Beach neighborhoods, the opening of the T-Third Street line and the F-Market-Castro to Fisherman's Wharf are now in place. Construction on the new Central Subway from the expanding Mission Bay neighborhood to Chinatown (and eventually to North Beach) is well underway, with revenue operations set to begin in 2019. MUNI continues to examine various timesaving solutions to the 150-year-old issue of transportation from downtown through the Richmond District to the Pacific Ocean. Significant changes to the large Parkmerced complex, adjacent to San Francisco State University (approved by the board of supervisors in 2011), will be phased in over a twenty-year period, significantly increasing density. MUNI is currently planning changes to the M-Oceanview streetcar line that will address increased ridership in the area, including the possibility of a subway segment on the M-line from St. Francis Circle to Holloway Avenue.

Love it or hate it, MUNI remains an important part of daily life for most San Franciscans—an ongoing relationship in which most residents remain deeply involved.

Chapter 5

SCHOOL DAYS

Sometimes my thoughts drift back to my own school days in the Outside Lands, beginning with Mrs. Beckerman's afternoon kindergarten class at Parksideside School in the fall of 1957. Following that, it was off to St. Cecilia, then to St. Ignatius (S.I.), both Stanyan Street and 37th Avenue, plus the University of San Francisco (after a one-year sojourn to Santa Clara University) and then a brief post-graduate stint at San Francisco State University (SFSU) in the 1980s.

Now I'll admit to being somewhat out of the loop when it comes to school rules that govern in this second decade of the new millennium. Recently, I was shown a copy of S.I.'s *Parent-Student Handbook*, which convinced me, once and for all, that my own high school days took place in a massive time warp, on the most remote galaxy of some distant, uncharted solar system. I could not believe that so many new rules were now in place at my old high school, as well as at many others.

Curious about what I had seen in S.I.'s rules, I explored further, studying a similar handbook issued by Mercy High School on 19th Avenue. Now, please don't get me wrong—I am definitely *not* criticizing the need to have such rules today. It's just that seeing some of these regulations in print forces me to acknowledge how very different things are since I graduated from St. Cecilia School in 1966 and became part of the high school scene from 1966 to 1970.

First of all, the rules now take up an entire printed booklet—our parents were sent just a few mimeographed pages of basics each summer before the

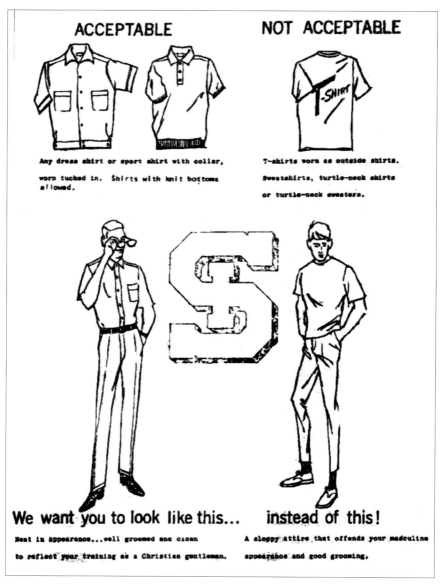

Throughout the 1960s, S.I. distributed its infamous dress code to new and returning students. The horn-rimmed glasses were optional. *Author's collection.*

new school year started. Short hair, shirts with collars, no jeans and polished shoes were the basic S.I. dress standards back then. There was always the sketch of a Bruce Bary–attired guy (complete with requisite horn-rimmed

glasses), contrasted with a T-shirt and jeans-wearing street thug, shod in "unpolishable" Clark's desert boots and looking like he should have a Marlboro hanging from his unshaven face, plus a beer bottle in one hand and a deck of cards in his hip pocket. We knew which one we *wanted* to resemble and which one we *had* to resemble, without a whole lot of words being written.

S.I., which has been coed since 1989, now has a dress code covering seventeen paragraphs across many pages and including words that never appeared before: "bare midriff," "bleached hair" and "multiple body piercing sites." Likewise, the Mercy handbook goes into great detail on this subject, even though there is still an official school uniform requirement in place there.

In the past, smoking was the big no-no, but S.I. now covers it in just two lines—summarized as "not within 5 blocks of school." Mercy goes into extensive additional detail, reminding both students and parents about health issues, and there's a stern reminder that purchasing or possessing cigarettes is a violation of California law for those under age eighteen, while recommending smoking cessation programs.

In the 1960s, S.I.'s policy on alcohol was simple: "Don't get caught with any." By 1966 or so, that policy had expanded to include drugs ("Don't get caught with any"). Today, the alcohol and drug policy covers two pages of detailed print, including "the right to subject any student at any time while on campus or at any school event, including sporting events, on or off campus, to Breathalyzer testing." While Mercy's rules do not call for impromptu testing, they do cite the legal penalties, including clear references outlining the criminal and financial consequences to parents for various violations. For those Mercy parents who may be doubtful, actual legal citations are provided, referring to specific laws by their numerical codes. This seems to be a subtle acknowledgement that perhaps girls are better controlled by parental influence and authority, while boys can best be deterred by the stark fear of being caught and embarrassed in front of their friends.

When we were teenagers—even when Dad and his older brother were S.I. students, in the 1930s—the big fear that parents and teachers had was…oh my…a deck of cards and a pair of dice. Today, all forms of gambling are outlawed at S.I. neatly and cleanly in a single sentence, while the "Technology Policy" covers a whopping five full pages of do and don't reminders about computers, laptops, phones, software, texting, tweeting and a variety of other electronic misbehaviors that were unimaginable ten or fifteen years ago, let alone in the Neanderthal times of the 1960s. Mercy's

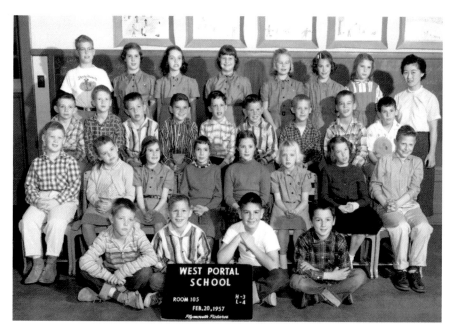

WEST PORTAL
SCHOOL

ROOM 105 H-3
L-4
FEB.20,1957

Miss Shigezumi's school class in 1957 at West Portal School reflects the impact of the baby boom on the size of public school classes in the Western Neighborhoods. *Grant Ute Collection.*

rules do not specifically address gambling (guess it's more of a "guy" thing), but they do go into far more extensive detail to prohibit a wide variety of electronic harassment activities, including "cyber-bullying."

S.I.'s rules for student conduct used to be summed up simply with a reminder that we should behave as "responsible gentlemen" at all times. Today, the rules for student conduct cover more than ten pages, with references to every objectionable situation that any teenager could possibly dream up. Some of the ones that we never had to think about are (in alphabetical order): "Alteration of Records" (don't), "Electronic Devices" (appropriate and inappropriate uses of), "Police Investigation" (lengthy rule requiring cooperation with), "Pornographic Materials" (prohibition against), "Public Displays of Affection" (the forbidden ones are clearly and graphically identified in enough detail that you don't want Grandma reading these rules without her cardiologist standing nearby), "Weapons and Dangerous Instruments" (all forbidden—including laser pointers, of all things) and something called "Wrong Place/Wrong Time" (be careful who you are hanging out with, because when they are caught doing something wrong, you are going to be in big trouble too, just because you were there at

the time). Mercy has chosen to remind parents and students about additional issues, such as "Courtesy to Cafeteria and Maintenance Staff" and "Proper Respect for Performers at School Events." I'm sorry, but beyond the age of kindergarten, no one should have to be told this at all—the knowledge and daily practice of such basic courtesies should be a given long before a person reaches high school.

S.I.'s rules also include a rather cryptic, "No private tutors allowed on campus." What does that mean? Did some student actually show up for class with a note-taking tag-along, just to help out with studying later on? This evokes images of Dobie Gillis's rich buddy Chatsworth Osborne Jr. Further research is needed on the reason behind this particular rule.

Behavior at sporting events is more thoroughly prescribed by the S.I. rules than by Mercy's. Among S.I.'s forbidden activities are: "Insulting the opponents' school or mascot, insulting opposing players, making unsportsmanlike, derogatory or obscene cheers or gestures." While I certainly support those ideas in principle, putting them into practice would seem to limit cheering to a rather unenthusiastic, "Go team!"—hardly the most rousing words that could be shouted from the stands. In today's world, it must be incredibly tough to be the head of the Art-Publicity Committee or the Rally-Dance Committee, both of which were always chaired at S.I. by guys who had fertile imaginations about slipping through a double entendre or two in posters and in cheers.

Even school dances are subject to some new regulations that would never have been deemed necessary in the past, such as S.I.'s "Freshmen are discouraged from attending the Junior or the Senior Prom." Discouraged? I don't think that any non-Junior or non-Senior would have had the audacity to try to attend one of those proms when I was there. And although most dances allow students to bring a "guest" (the word "date" is surprisingly absent) from another school, if a pass from the Dean's Office is obtained in advance, the venerable S.I. Christmas Dance is now closed to outsiders, thus forcing S.I. students to find a "guest" from within their own ranks. Face it, you don't always want to go to a dance with someone you've got to face as a chemistry lab partner every day—definitely a romantic deal-breaker, although perhaps that is a very subtle part of the plan.

Mercy has some unique rules, including a clearly stated prohibition on "inappropriate" dance pictures, clearly forbidding "sexy poses, sunglasses, dates with hats or caps." This rule makes ruffled shirt fronts, oversized velour bow ties, Madras jackets and other sartorial splendors of the past (that freaked our parents out big-time) look pretty mild in comparison. While S.I.

The location of St. Ignatius High School from 1929 to 1969. *Author's collection.*

Saint Cecilia School

GRADUATION BRUNCH · JUNE 10, 1966

Right Reverend Harold E. Collins, *Pastor*

Sister Mary of St. John, *Principal*

Graduating Class of 1966

Ahlbach, John	Cronin, Donna	Garvey, Edward	McCarthy, Steven	O'Hara, Kathleen	Scanlan, Tom
Ahlbach, Mary	De Benedetti, Patrick	Gautier, Gary	McDonald, Alma	O'Loughlin, Terry	Schiefer, Theresa
Ahlquist, Robert	Del Bene, Mark	Gavin, Theresa	Meagher, Christine	O'Reilly, Sean	Shea, Susan
Aiello, Mario	Doherty, Daniel	Giorgi, David	Mendoza, Dennis	O'Rourke, Teresa	Sjostrom, Kerstin
Ammiro, Frank	Donohoe, John	Gonzales, Katie	Miller, Herbet	Panos, Nancy	Smith, Roger
Asplund, Yvette	Dunnigan, Frank	Grenfell, Beth	Molinari, James	Parrott, John	Straub, Catherine
Baca, Arlene	Esposito, Kathryn	Haran, Mary Cleere	Morales, Ralph	Pengel, Mark	Sullivan, Dave
Baireuther, Francine	Feeney, John	Hazard, Thomas	Mullen, Theresa	Pioli, Nancy	Sullivan, Joanne
Black, Bill	Feerick, Diedre	Hernandez, Mark	Murphy, Gene	Portman, Kathleen	Sullivan, Marianne
Brady, Robert	Fiesel, Blanche	John, Patricia	Murphy, Robert	Quinn, Dennis	Tipple, Theresa
Bricca, Elizabeth	Fitzgerald, Bradlee	Johnston, Mary Jo	Murphy, Christine	Raggio, James	Tomasini, Philip
Buick, John	Fitzpatrick, Kathleen	Lehane, Jane	O'Brien, Rosemary	Ramirez, Theresa	Van Laak, Debra
Carberry, Kathy	Fox, James	Lewin, Mary	O'Callaghan, John	Renstrom, Alison	Walsh, Fred
Collopy, Claire	Fredriksson, Susan	Leytem, Cindy	O'Callaghan, Theresa	Renstrom, Susan	Walsh, Milton
Cornell, Paul	Froehle, Ellen	Lucas, Larry	O'Connor, Kathleen	Rey, Linda	Wilson, Nancy
Corsiglia, Therese	Gallagher, Michael	Lynch, Gregory	O'Dwyer, Doreen	Rigg, Dennis	Winkelbaur, Jerry
Costello, Larry	Ganey, Michele	Lynch, Michael	O'Farrell, Margaret	Ruck, Christine	Wolohan, Kathleen

Sister Maureen Theresa, Room 15		Sister Maria Anna, Room 14	
John Feeny, *President*	Patty John, *Secretary*	Fred Walsh, *President*	Jim Raggio, *Secretary*
Mary Ahlbach, *Vice-President*	John Ahlbach, *Treasurer*	Kathy Esposito, *Vice-President*	Katie Gonzales, *Treasurer*

St. Cecilia School class roster from 1966 shows that Catholic schools of that era often had fifty or more students per classroom. There was only one teacher and no classroom aide. *Author's collection.*

Washington High student body card. Until the mid-1970s, San Francisco public schools enrolled students in the fall and again at mid-year, resulting in "split classes" with both mid-term and June graduations. *Judy Hitzeman Collection.*

The football field at George Washington High School has had a magnificent view of the Golden Gate Bridge and the Marin headlands since 1936. *Tammy Aramian photo, 2005.*

specifically bans laser pointers at all times, Mercy declares, "Glow sticks and any glow items are not allowed at dances."

There were always chaperones—a handful of faculty members and a few parents—whose kids usually danced in the far corners of the gym or else stayed away altogether, to ensure proper decorum. Today, there are numerous clearly spelled-out prohibitions in the S.I. handbook that define "sexually explicit dancing" in detail (again, don't let Grandma read this unsupervised), and the penalties for rule infractions are clear—parents will be called to take the student(s) home, and disciplinary action may follow. Mercy simply cautions students against "dirty dancing."

The rule that surprises me the most (and was probably the most frequently violated one in my day) is S.I.'s "Off Campus Without Permission" note. A full week of detention is the penalty for the first offense, and after that, "A second offense, any time throughout a student's term at St. Ignatius (S.I.), will result in automatic suspension from school." Whew. Some of us should be grateful that these rules don't have a retroactivity clause! Mercy takes the same stand against unauthorized absences, but there, the penalties are not nearly as severe. Again, like gambling, perhaps this is more of a "guy" thing.

Given the fact that S.I. went coed in 1989, there is, of course, a "Pregnancy Policy," and it's a rather enlightened one—"continue with classes as long as medically advisable"—combined with a clear prohibition on abortion as an option. I can think of some priests and nuns in days gone by who might have advocated public stoning, but the Jesuits, for the most part, have always been far more practical when looking at the realities of life. Mercy's policy is a bit more circumspect, being entitled "Pregnancy and Marriage" and stressing that decisions are made on a case-by-case basis; there is no guarantee of continued school attendance nor, surprisingly, any clear statement of the Catholic Church's position on abortion.

Surprisingly, only a few Jesuits appear in the listing of S.I.'s administration, faculty and staff, while Mercy has only three nuns in its list. However, knowing a handful of current Catholic school lay faculty personally, I am convinced that they are all academically very bright people who have the ability to communicate well with the students. Reading the list of names and viewing photos on the websites of both schools further convinces me that S.I. and Mercy have both achieved significant diversity of gender, race and ethnic background among their teaching and counseling staffs, so that today's broad spectrum of the student populations at each school is well reflected.

For all the changes, though, one thing remains the same across the years: your high school friends will be friends for life. They will find

Lowell Celebrates!

50th Anniversary of the Eucalyptus Drive Campus

Saturday, April 13, 2013
10 am to 4 pm

Lowell Alumni Association • PO Box 320009 • S.F., CA 94132-0009
Phone: (415) 759-7830
Website: www.lowellalumni.org

Lowell High School, the city's original academic college prep school, celebrated fifty years at its Lake Merced campus in 2013. *Paul Rosenberg Collection.*

you dates, bail you out of jail, surface as co-workers throughout your career, participate in your wedding, serve as godparents to your children, console you when your employer practices downsizing, take you in when you experience marital or other familial discord, be there when you have to bury your parents, share your joy as your first grandchild arrives and then appear as your neighbor, with a long history of memorable stories, when you are settled into your chosen retirement community. Trust me, all of this has continued to unfold in my life and the lives of my friends over the past forty or more years.

A.M.D.G.

ONE HUNDRED ELEVENTH ANNUAL

Commencement

of

𝔖𝔱. 𝔍𝔤𝔫𝔞𝔱𝔦𝔲𝔰

𝔒𝔬𝔩𝔩𝔢𝔤𝔢 𝔓𝔯𝔢𝔭𝔞𝔯𝔞𝔱𝔬𝔯𝔶

SATURDAY, JUNE 6, 1970

ST. IGNATIUS CHURCH

San Francisco, California

The 1970 graduation program for St. Ignatius. Established as an all-boys school on Market Street in 1855, it was renamed "College Prep" in the fall of 1969, when the 6th campus was dedicated in the Sunset District. It has been coeducational for twenty-five years now and serves a diverse student population. *Author's collection.*

Meanwhile, S.I. today has a particularly troublesome rotating block schedule involving a student's numbered sequence of courses: 1-2-3-4-5-6 on Mondays, followed by 7-1-2-4-5-3 on Tuesdays, 6-7-1-4-5-2 on Wednesdays and 3-6-7-4-5-1 on Thursdays, plus a special schedule observed on Fridays. Mercy, on the other hand, has a schedule that includes White Day, White Flip Day, Red Choice/Assembly Day, Red Flip Choice/Assembly Day, Red Long Assembly Day, Red Flip Long Assembly Day, Red Faculty Day, Red Faculty Flip Day, Red Minimum Day and Red Minimum Flip Day. Whew!

Those schedules are far more than my addled brain can comprehend at this age, so I guess it's a good thing that high school is still for teenagers.

Hmm, I wonder if I could still ace the SAT with the same 1490 score that I made back in the fall of 1969?

Many public and private schools with strong ties to the Western Neighborhoods have closed or merged over the years. These gone-but-not-forgotten schools include the following.

Public Elementary Schools

- Cabrillo Elementary—735 24th Avenue; closed in 2006.
- Columbus School—1541 12th Avenue, reopened as Alice Fong Yu Immersion School, 1995.
- Crespi (Juan) Home School—Opened in the 1950s near Lincoln High; now a health center.
- Diamond Heights School—350 Amber Drive; closed in the 1980s.
- Farragut School—Holloway Avenue and Capitol Avenue, closed in the 1980s.

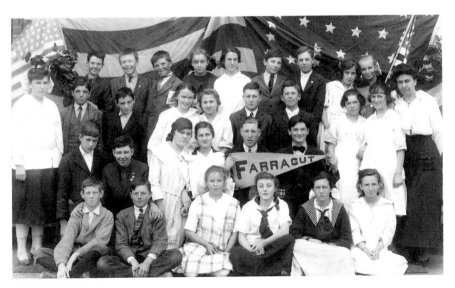

Farragut School class of 1917. A long-serving school in the Ocean View neighborhood, Farragut was demolished in the 1980s. *John Gross Collection.*

- Frederic Burk—Public elementary school serving the Parkmerced community; closed in the early 1980s.
- Laguna Honda School—Red brick school on 7th Avenue became Newcomer High School; now closed.
- Mark Twain Elementary—1920 41st Avenue; reopened as Sunset Elementary.
- Noriega Home School—Opened in the 1950s on 44th Avenue; now a public preschool.
- Parkside School—24th and Vicente; demolished and rebuilt as Dianne Feinstein Elementary.

Public High Schools

- McAteer High School—Built as a replacement for Polytechnic High School and named for state senator J. Eugene McAteer, who died unexpectedly in May 1967 during his campaign for mayor. It is now the Ruth Asawa School for the Arts.
- Polytechnic High School (1895–1972)—A veritable sports powerhouse, Poly faced some rough going in the mid-1960s. In 2005, the alumni newsletter (www.perennialparrot.com) documented the school's rise and fall. Poly's official playing field was Kezar Stadium, built in 1925, home to the city's annual football championship, as well as

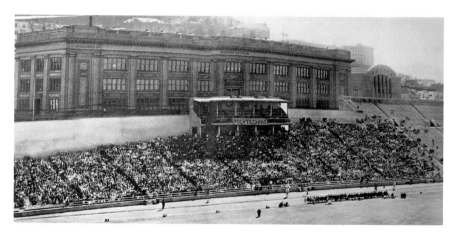

Kezar Stadium served the adjacent Polytechnic High School and its students until 1972 and was the scene of many football championships for other San Francisco high schools as well. *Kathy Bertsch Compagno and Alan Brimm artwork.*

professional football later. The 1928 playoff game between Poly and Lowell attracted more than fifty thousand fans, an unbroken Northern California attendance record for a high school football game. The loss of professional football in 1971 and the closure of Poly in 1972 led to the stadium's slow decline. In 1989, Kezar was demolished and rebuilt with a much smaller seating capacity of just ten thousand.

Catholic Schools

ELEMENTARY
- St. Emydius School—Ashton and DeMontfort parish school opened in the late 1930s and closed just after the turn of the millennium due to declining enrollment, with the gym remaining open. The school building itself is now occupied by a private school.

HIGH SCHOOLS
- Presentation High School—Turk and Masonic all-girls school was closed in 1990; property was sold to USF.
- Sacred Heart Cathedral Prep—Result of a 1987 merger of Sacred Heart and Cathedral (successor to St. Vincent's).
- Star of the Sea Academy—9th Avenue and Geary; this all-girls school closed in 1986.
- St. Rose Academy—Pine Street all-girls school was closed and demolished because of damage from the 1989 earthquake.
- Other San Francisco Catholic girls' high schools that have closed since the 1960s include Notre Dame des Victoires (French) on Bush Street, Notre Dame deNamur on Dolores Street, St. Brigid's on Van Ness Avenue, St. John's Ursuline on Mission Street, St. Paul's on Valley Street, St. Peter's on Alabama Street and St. Vincent's on Geary.

Colleges

- Lincoln University—Founded in San Francisco in 1927, this private college operated for many years in Pacific Heights before moving to the old Presentation Convent at Turk and Masonic. It relocated to Oakland in 1999, and USF then acquired the old Presentation Convent after having already taken over the classroom building.

- San Francisco College for Women—Located at Turk and Parker, this four-year college became coeducational in 1969, changing its name to Lone Mountain College. On the verge of closing in 1978, it was acquired by the neighboring Jesuit-run University of San Francisco and is now USF's Lone Mountain campus.

Chapter 6

Who's Been Working
on the Railroad?

A s youngsters growing up in the 1950s, we interacted with family, friends and neighbors who held a wide variety of occupations. Not everyone in our parents' generation had the good fortune to attend college, but all of them earned decent livings and were able to support themselves and their families comfortably in a wide variety of employment situations that required little more than a basic education combined with a pleasant nature, persistence and punctuality.

As a preschooler, watching the neighbors march off to work each morning from my front window vantage point, I could see an enormous array of occupations represented—both skilled and unskilled labor, the professions, government service, public safety, education, shopkeepers and more. I knew that there were many different careers to choose from when I grew up, but it never dawned on me that so many of the jobs that I saw represented on those long-ago foggy mornings would disappear from the San Francisco landscape almost entirely during my own working years.

Police and firefighters were popular careers that captured childhood imaginations; who among us didn't aspire to one of those jobs? In grammar school, we often visited firehouses or met police officers up close. In fact, one of my grammar school classmates had four sisters who all became members of the SFPD, one of whom recently retired as deputy chief. Sad to say, though, that many of those who joined the police and fire departments after the mid-1970s did not remain living in San Francisco. It's often been said that the safest place in the Bay Area is the Marin

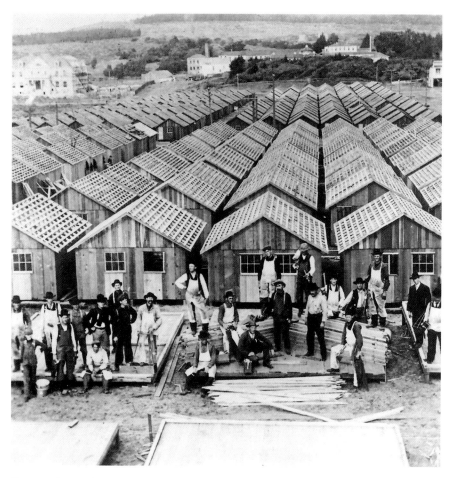

Construction workers building earthquake shacks at Camp Richmond, near present-day Park Presidio Drive, 1906. *WNP Collection.*

County city of Novato, given its extraordinarily high population of both SFPD and SFFD personnel. Let's just hope that there's no backup on the Golden Gate Bridge the next time that a major event occurs that requires these folks to be on duty on short notice.

In addition to police and fire department employees, many San Franciscans also worked for the city in various other occupations. We knew a few gardeners in Golden Gate Park and others who were part of MUNI's vast army of "inspectors" who would ensure that the rolling fleet was on time— one regular Outside Lands correspondent reported recently that a schedule deviation of even two minutes used to be cause for a serious reprimand for a

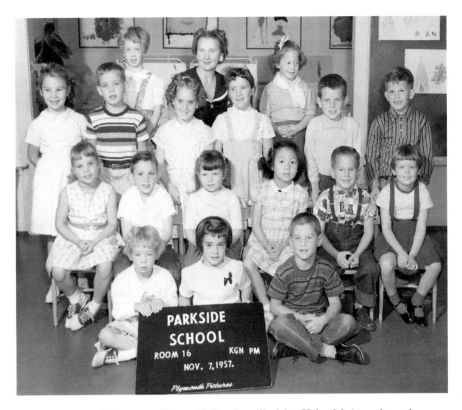

Parkside School, kindergarten, Room 16. Teachers like Mrs. Helen McAtee, shown here with her 1957 afternoon kindergarten class, spent many years working for the San Francisco Unified School District. *Christine Meagher Keller Collection.*

MUNI driver in the old days. Judging from recent experiences, a lot of jobs like that one have disappeared entirely.

One of my dad's USF classmates occupied an elective office at City Hall, but the fellow never considered himself a politician, and he never ran for another office—he just continued serving in the same capacity, year after year, becoming more and more skilled at the many intricacies of his job. Today, that position is highly politicized and now just a required waystation for politicians.

Many women were involved in the San Francisco Unified School District and in the public library system. Some chose to remain in the front office or the classroom for their entire careers, while others moved up the ranks to positions of dean, assistant principal or principal. Today, current news stories of classroom violence, budget cutbacks and annual layoff notices have been

successful in discouraging many of the best and the brightest from pursuing this civic-minded career that was once highly thought of.

Even state employment is not the same. San Francisco, with a large and diverse workforce and excellent public transit, was once considered the ideal place to locate federal and state offices. Today, due to rising real estate costs, many agencies are relocating to remote, less costly areas. In addition, today, many government employees are faced with furlough days, reduced hours, pay caps and ever-increasing workloads being handled in offices that are more and more distant from where they actually reside.

My dad and his brother spent more than forty years each with the post office, retiring in 1975 as station managers, exactly the same job that their father held from 1894 to 1934. Their grandfather also worked for the post office, from 1860 to 1894, loading and unloading sacks of mail at the Pacific Mail Steamship Company docks on the waterfront. With 150 years of family history working for such a "stable" institution, it is troubling to read that the U.S. Postal Service remains in constant danger of financial collapse, even with ongoing rate increases and the prospect of Saturday home delivery being eliminated.

One of our neighbors owned and operated a small sheet metal manufacturing shop that might have celebrated its 100th anniversary recently if it were not for the changing times. Another neighbor went to work for his family's second-generation rope and rag manufacturing business in the 1930s and continued it into the third generation in the 1960s, with his daughter, the fourth generation, working summers in the office. The declining demand for such products, plus stricter zoning laws, have both contributed to the closure of many such firms.

The Western Neighborhoods were once filled with tens of thousands of men and women involved in customer service or bookkeeping activities for major employers like PG&E, AT&T and Standard Oil. These employers represented the epitome of steady employment for decades, and my neighbors had lifelong careers, usually involving a telephone headset or a pencil and an adding machine, at desks that filled many of the most prominent buildings along Market Street and elsewhere in the downtown area. Today, these basic, well-paying, secure jobs have been outsourced to every country around the globe, whose inhabitants are presumably marching off to work each day, as happy and secure as my neighbors were when I watched the morning parade to work back in 1955.

And what about the banks? Montgomery Street and the rest of downtown literally teemed with banking houses that employed vast numbers of San

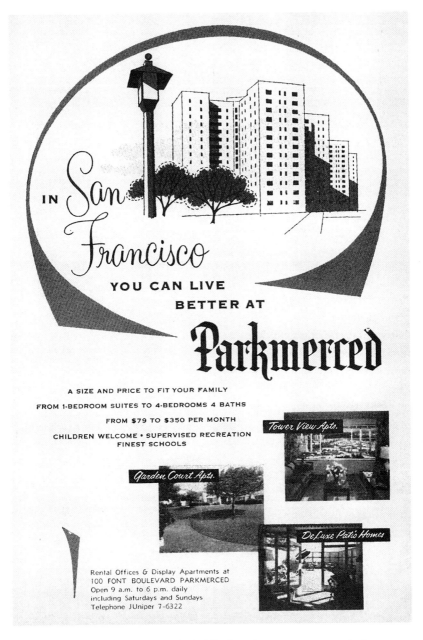

Parkmerced rental advertisement, 1950s. The low-rise apartments were built by Metropolitan Life before World War II, and the eleven tower buildings were added later, employing thousands of construction workers. Five blocks of garden apartments near the SFSU library were sold to the university for student housing in 2005 and are now known as University Park–South. Major renovations to the remaining 3,221 units are now underway. *Courtesy of Prelinger Library.*

Franciscans. When I was growing up, we knew many people who worked for Wells Fargo or Hibernia Bank, along with two longtime family friends who had been with Bank of America since its pre-1930 Bank of Italy days. Today, following decades of mergers, bankruptcies, takeovers and just plain idiotic management, many San Francisco banking establishments no longer exist or else no longer perform large segments of their business in the city. The absence of those firms took tens of thousands of jobs (with benefits like steady, full-time employment, health and retirement plans and discounts on home/auto loans and credit cards) that provided a backbone of stability for many households. The introduction of ATMs in the 1980s contributed directly to the elimination of thousands of local bank teller positions.

Most of us kids understood jobs like supermarket checkers from an early age, since we had a bird's-eye view of such activities from the little seat at the front of the grocery cart. We also saw that other people filled the shelves and still others cut meat with those large, noisy electric saws. It was our family friend Martha who explained to me that while she worked for Del Monte Corporation, she was not selling the product (nor was she picking it from trees and vines nor packing it into cans and jars nor stacking the boxes onto shelves); rather, she was paid to review written reports of exactly how many cans of peaches were sold versus how many cans of pears. As I grew older, a job involving the financial end of the business suddenly emerged as a far more interesting career possibility than positions that involved calling out, "That's 2 for 29," or today's ubiquitous, "Paper or plastic?" Strangely, a recent look at Del Monte's website showed no local openings for accounting jobs like Martha's. Instead, there were exactly six jobs listed in San Francisco, all of which appeared to be fairly high-level positions that would not be available to anyone who did not possess both an advanced educational degree and many years of highly specific food industry experience.

Furniture and department stores, along with the major men's and women's clothing and shoe retailers, were once considered to be excellent employers, but look how many have disappeared: Emporium, White House, City of Paris, Liberty House, Bullock's, Butler Brothers, Weinstein Company, Hale's, Sterling Furniture, Lachman Brothers, Redlick's, I. Magnin, Joseph Magnin, H. Liebes, Ransohoff's, Livingston's, Roos-Atkins, Grodin's, Sommer and Kaufmann, White Front and more. In addition to these, some national retailers have given up on San Francisco entirely—J.C. Penney, once a cornerstone at 5th and Market, has been gone for more than forty years, and Sears, which used to have two stores in town, abandoned its final location at Geary and Masonic more than twenty

Emporium Dome. The Emporium provided solid unionized career employment for thousands, particularly women, for many decades. The store's dome, rebuilt after the 1906 fire, was reengineered for a 2006 expansion of the Westfield San Francisco Centre shopping complex. *Tammy Aramian photo.*

years ago. Even among the newer retailers, Williams-Sonoma, which once employed hundreds of full-time and part-time catalogue sales and customer-service staff in spacious offices near the Embarcadero, offering decent wages, health benefits and generous merchandise discounts, began moving these jobs to other states in 1997.

Our neighbor Bill had been in the wholesale paper business for years, working as a sales manager for a stationery and envelope company. His firm's clients were long-term and steady, and their needs were never-ending: corporate stationery, invoices, notepads, telephone message pads, business cards, preprinted index cards, accounting paper, continuous-feed computer forms, newsprint, carbon paper, advertising postcards, blank checks and more. All of this provided him with a steady income and his family with a comfortable lifestyle. The advance of technology has rendered this career nearly extinct.

We knew people who owned and operated small businesses along Taraval or Noriega or Irving Streets: a coin laundry, a liquor store, a hardware store

and a shoe store. Today, all of these places are gone. Our friend Theresa was the office manager for board of supervisors member James Sullivan in his West Portal real estate/insurance office. Following Sullivan's untimely death in 1961, Theresa took over the insurance side of the business, which she ran alone out of her home office for the next twenty-five years until she retired. Today, the independent insurance agent, representing a variety of companies, is a rarity, and many of us fall back on one big-name company or the impersonal help online or at the other end of a toll-free number for all of our needs. Today, it is increasingly difficult to find any sort of insurance agent in a nearby office.

And whatever happened to gas stations? There used to be a Flying A station near West Portal, on Ulloa near the Twin Peaks tunnel (now a tiny city parking lot). Shell and Union were kitty-corner from each other at 14th and West Portal, and Chevron was just a block away at 15th. There were dozens of them along Taraval—Arco at 14th Avenue; two more stations at 15th Avenue; and three at 19th Avenue; plus Richfield, Texaco, Mobil and Phillips 66, along with the tiny independent ones at least every other block, all the way to the beach. Now you can practically count them on the fingers of one hand. What happened to the young kids who used to find a first job there or the older guys who had all the automotive experience in the world and who could fix anything? There just seems to be no place for any of them in the today's San Francisco working world.

For students in Catholic schools, it went without saying that a call to the religious life, as a priest or a nun, was highly viewed by the Church, family and society in general. In those days, both St. Cecilia and its ecclesiastical neighbor, Holy Name parish, used to vie for how many priests and nuns had graduated from each of the grammar schools. In addition to keeping track of those numbers, a careful count was also maintained of the graduates from each parish's school who were then studying in one of the various seminaries or convents. Changes involving the role of women in the workplace, plus the ecclesiastical tumult that seems to have begun in the late 1960s, along with gross improprieties on the part of some priests, have all combined to forever alter the stature surrounding a vowed religious life. When was the last time you heard of a friend's or relative's working-age child making such a choice?

Growing up, it seemed that every boy had a play doctor's bag (and every girl a play nurse's kit), filled with the requisite bottles of candy "pills" and sweet syrup "medicines," and I must acknowledge that more than a few of my classmates ended up in those careers for completely altruistic reasons.

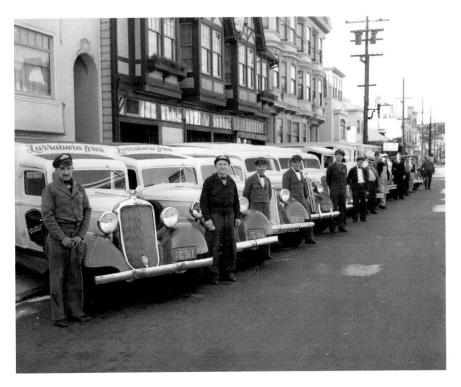

Larraburu Bros. bakery vans on 3rd Avenue in the Richmond District, 1940. A beloved baker of French bread for decades, the firm went bankrupt after an underinsured vehicle accident in the 1970s. *John Freeman Collection.*

Today, however, few in the medical profession seem to be in general practice in any convenient neighborhood locations. Managed care has drastically reduced doctor-patient direct contact, and the result has been that many patients feel rushed and uncertain of when it is appropriate to mention their concerns to a doctor.

Another neighbor, an attorney (and just like Perry Mason), was a role model who exuded poise, compassion and a pretty good intellect. Today, however, many people have their own personal horror stories of having to hire attorneys to deal with problems created by prior attorneys, and the law is now a career that seldom suggests the nobler instincts of life.

One of my dad's cousins, a 1943 Cal graduate, came home from World War II in 1945 and spent the next thirty-seven years as an architect-engineer with Bechtel, earning a comfortable salary and benefits along the way, while contributing to major local civic improvements such as BART. Today,

many companies often bring on people like this as consultants who never become part of a permanent staff—they simply come to work, complete an assignment and are then gone, pushed out the door unceremoniously.

The fade of trade unionism—particularly along the San Francisco waterfront and its long-gone warehouses, packing plants and truck yards—has forever dimmed the draw of a solid career in blue-collar industry, along with its promise of lifetime financial stability. Again, much like the customer-service positions with the big utilities, many of these jobs have gone so far offshore that they will never again see the lights of San Francisco.

One of our neighbors was an engineer for the Belt Line Railroad along the Embarcadero. How I wanted to be a train engineer after I got to know him and hear his stories—alas, the closest that I ever got was Lionel. You would be hard-pressed to find even a retired railroad engineer in San Francisco today. A few years later, as a twelve-year old, I was attending a bon voyage party with my parents for some neighbors who were embarking on cruise to Hawaii, and I was lucky enough to get a tour of the bridge on the old Matson liner *Lurline*, then plying a regular route from San Francisco to Honolulu. I decided then and there that becoming a ship's captain was what I really wanted to do, but in the flash of a passing jet plane, that career also evaporated into the foggy mists of the past.

It's hard to imagine what today's kids are going to be doing in their working lives twenty, thirty or fifty years from now, but it appears that their choices will never be quite as wide-ranging as they were for all of us, growing up at a time when we really could be anything we chose, in a city that had the greatest variety of careers in the world.

Chapter 7
DINING OUT

San Franciscans seem to enjoy dining out more frequently than residents of most other cities. At the time of the Gold Rush, when both food supplies and kitchen facilities were sparse, restaurants sprang up to serve the needs of the miners and others who had arrived in the city. Today, with a diverse working population—often working long hours and/or commuting great distances—eating out is an essential part of the day for many.

We tend to favor the small, one-of-a-kind, hole-in-the-wall places, but we also enjoy those that are a bit bigger and splashier. The Cliff House has been serving up food, drink and spectacular views above Seal Rocks for 150 years now, and overflow crowds can easily walk up Point Lobos Avenue to Louis' Restaurant, a recently restored 1930s charmer. Ville d'Este on Ocean Avenue, an Art Deco gem, has been there in various incarnations since before World War II. Beach Chalet, once known as not much more than a VFW hall, has had a great restaurant on the second floor, complete with magnificent ocean views, for nearly 20 years. Mel's Diner, on Geary near Stanyan in the Richmond, was a popular spot with students from nearby (S.I.) in the 1960s. It became a stereo store circa 1974 and then reemerged as Mel's in 1988, evoking memories of late nights after finishing up marathon yearbook projects (at the time of this writing, there are plans to replace Mel's with yet another multi-unit housing complex). Meanwhile, the Tennessee Grill on Taraval has been dispensing hot breakfasts in the Sunset since the early 1950s, even though many similar spots have come and gone in that timeframe.

It's no surprise, though, that many places close each year. Issues such as leases, changing tastes, parking availability, competition and the fickle finger of fate—what's "in" and what's "out"—can bring down the best of them. Zim's was a powerhouse, serving breakfast, lunch and dinner from its opening in 1948. Its success peaked in the 1970s with dozens of Bay Area outlets, but in 1995, it was suddenly gone. Grison's on Van Ness welcomed diners from the 1930s until the 1980s, with two locations, then one and finally none. Nearby Hippopotamus Hamburgers was the city's first upscale hamburger place in the 1950s, and then suddenly it also vanished from the scene. Yet Wah had been out there at 23rd and Clement for decades, serving great Chinese food in an impressive atmosphere to patrons who came from all over the Bay Area, braving both fog and limited parking. It, too, closed suddenly in the second decade of this millennium, leaving many people without their favorite neighborhood spot.

Small places that once packed them in for decades—Miz Brown's on California Street, Café Riggio and Le Cyrano on Geary, Luzern on Noriega, Café for All Seasons on West Portal and Lakeside Café on Ocean Avenue—have all disappeared in recent years, while the iconic Blum's in Stonestown and other locations vanished into the mists decades ago, along with its spectacular Caramel Crunch Cake.

The year-long closure of nearby Westlake Joe's (said to be reopening in 2015) has been truly traumatic for many locals. Likewise, the 2012 demise of Caesar's, which had been operating since 1956 at Bay and Powell in North Beach, sent shock waves throughout the city. Longtime residents in every neighborhood were familiar with the seven-course moderately priced Italian meals there, and many families had fond remembrances of the place for various family occasions. However, as the restaurant's regular customers aged and often moved out of San Francisco, their visits became less less and frequent. In the words of the owner, "People who would come in every day for lunch now come in once a month," and many San Francisco newcomers were simply not interested in the same type of cuisine—sad but true facts of life in an ever-changing metropolis.

Without a doubt, the cool, foggy atmosphere of San Francisco lends itself well to pubs and taverns, and there is no shortage of these in the Western Neighborhoods, although the actual number may be somewhat smaller than fifty years ago, given the new emphasis on general health matters, as well as on the importance of unimpaired driving. The Little Shamrock on Lincoln Way near 9th Avenue has been dispensing liquid refreshment since it opened in the late 1800s, catering to Irish workmen constructing the nearby Midwinter Fair of 1894, and the Philosophers Club on Ulloa, near the West Portal entrance to the Twin Peaks Tunnel, has been serving a clubby, post-

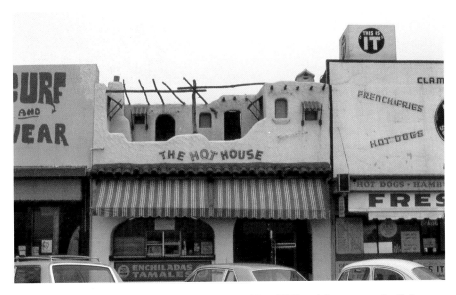

Operating on Great Highway at Playland from 1934 to 1972 and then on nearby Balboa Street until 1996, the wonderful tastes and aromas of the Hot House may soon return, as the son of the former owner explores the possibility of reopening the popular restaurant in a new location. *Dennis O'Rorke photo.*

collegiate clientele since the days when Harry Truman occupied the White House. The Inner Richmond streets of Clement and Geary have catered to San Franciscans citywide with such popular spots as the Abbey Tavern, Plough and Stars and the 540 Club for more decades than most of their patrons have been alive. We all have a favorite place or two, but the more detailed stories of these places will have to wait for another time.

Yet sometimes change can be good. Just in this millennium, Valencia Street in the Mission has become a veritable "Restaurant Row," with a wide range of cuisines represented. Bakeries, which seemed to be in a death spiral citywide in the 1990s, have made an amazing comeback—new pie shops in the Mission, tiny spots with outdoor seating in the far reaches of the Sunset along Judah and Taraval, trendy cupcake bakeries in Hayes Valley and an incredible variety of small neighborhood eateries in areas like Bernal Heights, Potrero Hill and Noe Valley—all just waiting to be discovered as the next magnet dining spot for residents from all over the city.

Many all-time favorite destinations five years from now are likely still in the minds of their future owners, who are thinking out the details of taking over a tiny vacant storefront on a nearby commercial block near you!

Chapter 8

LET'S GO SHOPPING!

Shopping was once a pleasant activity that we undertook with local merchants who lived among us before Starbucks, Walgreens, Olive Garden, Safeway, Subway, Supercuts and others infiltrated the neighborhoods. Walking down an Outside Lands street in the 1950s or 1960s, you might find yourself doing business with some of the following.

John and Victoria Dekker, who lived on 39th Avenue near Irving, took over a former Goodwill Store at the northeast corner of 20th Avenue and Irving circa 1961. Completing most renovations themselves—hard to imagine today!—they opened Dekker and Sons Sporting Goods (or Dekker's). The store was stocked with popular merchandise, including the "must-have" athletic shoe of the day, Converse Keds. The choices were simple: either high-top or low-top, black or white, and the entire back wall was stacked high with boxes.

The store's name recognized the three sons who played baseball at S.I.—Ken (1959); John, aka "Rock" (1963); and Jim (1968)—all of whom made All-City. The only other family threesome to make All-City in baseball are the Cole brothers of Polytechnic High: Marty (1966), Rick (1968) and Chris (1971)—and no, the three DiMaggio brothers are *not* recorded as having reached this same achievement.

Dekker's became a neighborhood institution for its shoe selection and service and also for the variety of other sporting goods it carried. The second floor contained a "swing room" with hundreds of bats of all weights and sizes. Customers could practice swinging until they found the perfect bat—see if you can find that at any big-box retailer today!

Christmas decorations above West Portal Avenue, December 1947. The street has been a neighborhood shopping enclave for more than ninety years. *Jack Tillmany Collection.*

Dekker & Sons was a popular sporting goods store at 20th and Irving in the 1960s. *Dekker Family Collection.*

For years, the store's main competition was Flying Goose at 24th Avenue and Taraval Street and Dave Sullivan's at 17th Avenue and Geary. By the end of the decade, large franchise stores, including some in Daly City, were selling athletic shoes at deep discounts, and circa 1967, they began something previously unheard of—opening on Sundays. Eventually the Dekker family sold the business, and the corner then housed Sunset Sporting Goods for a few years before evolving into yet another bank.

The following are memories of some other businesses where customers interacted with owners who were also neighbors. Like Dekker's, all these places featured reliable products/services, good values and friendly, personal attention—that's why we remember them, even today.

ADELINE BAKE SHOP—A West Portal fixture (plus downtown locations) for decades since the 1950s. Owned and operated by the Lembo family, living nearby on Wawona, Adeline had the best Danish pastry in the neighborhood, but the last of the shops closed in the late 1990s.

THE ALTERATION SHOP, 1145 Vicente Street—Operated by elderly Miss McKinley, who lived in the same building, offering same-day service if needed. Mom, who was barely five-foot-four, relied on her for years to alter the hemline of every dress, skirt and pair of slacks that she wore.

BARONIAL BAKERY, 1033 Taraval Street—Operated by the Nabbefeld family, who lived at 24th and Vicente. They provided birthday and graduation cakes for our family from the 1950s until the 1970s. Their chocolate layer cake with the glossy dark frosting was a family favorite for "company."

CAREW AND ENGLISH, 350 Masonic Avenue—Operated at the easternmost edge of the Outside Lands for decades by the Carew family, whose members lived in Jordan Park and Forest Hill. Most of our 18th Avenue neighbors did business here, as the need arose, until the firm merged with the downtown-based Halsted's.

CHICKEN DELIGHT, 3828 Noriega Street—"Don't cook tonight—call Chicken Delight!" That classic jingle managed to sell hundreds of dinners throughout the Western Neighborhoods every night from a tiny shop on outer Noriega, another at 21st and Geary and others throughout the city. Founded in Illinois in 1952 (the same year as Kentucky Fried Chicken), Chicken Delight had grown to more than one thousand locations by the early 1960s, easily beating out its rival. Mom and her friends seemed to like this place, and I can recall several satisfying dinners delivered from there on rainy nights, circa 1963–66—a bucket of various fried chicken pieces, plus side dishes of coleslaw and blueberry muffins. With a large lighted

plastic chicken wearing an apron (as kitschy as the Doggie Diner logo) on the roof of delivery cars, word-of-mouth advertising was instantaneous. A late 1960s corporate takeover of the company failed to enforce the original quality standards, and many newer outlets flopped, thus pulling down the whole company's reputation. A Canadian store owner bought what was left of the chain in 1979, and with strong management oversight and rigid quality controls back in place, franchisees now operate successfully, but only in eastern Canada, New York and New Jersey.

COURTING'S STATIONERS, West Portal Avenue and Stonestown—Operated by Anna Courting, who lived on Magellan Avenue. Courting's sold everything from greeting cards to office supplies in two convenient locations.

DAVE'S A-1 PHARMACY, 1755 Noriega Street—Operated by Dave and Mary Shayman, who lived at 14th and Lawton. Dave's was larger than some drugstores of the era, carrying more items. Their daughters worked there on weekends.

EL SOMBRERO, 23rd and Geary—Operated by Bill and Alicia Bernal, who lived nearby on Clement Street. A Friday or Saturday evening of Mexican food at this wonderful spot prompted people to dress up a bit. Street parking was very easy back then.

EMERALD CLEANERS/TAILORING, 1730 Noriega near 24th Avenue— Operated by Harold and Helen Bloom, a charming old-world couple who lived at 40th and Ulloa. I was having some suits altered in 1982 after losing fifty pounds on Weight Watchers, when Helen, multiple threaded needles in her lapels, pulled me aside and whispered, "Dahling, are you eating okay? Let me bring you some of my nice chicken soup…"

ERNIE'S NEPTUNE FISH GROTTO, 19th and Irving—Operated by Ernest and Ruth Aviani, who lived at 22nd and Judah. My parents were Friday night regulars in the 1950s, and I developed a lifelong passion for Bay shrimp here.

FAY CLEANERS, 1434 Noriega Street—Operated by Miyoshi and Akiko Kazuyei, who lived on 4th Avenue near California Street. Excellent work and reasonable prices, and Akiko always offered to clean light-color garments "in a fresh solution."

FLORENCE DELICATESSEN, 2115 Irving Street—Operated by Lois Ross, who lived nearby on 22nd Avenue. This was a veritable replica of Herman's on Geary. I can still smell the sliced meats, cheeses, pickles and olives, as well as the incomparable cooked ravioli in sauce.

FLYING GOOSE SPORTING GOODS, 24th and Taraval—Operated by Philip and Elsie Gosland, who lived at 33rd Avenue near Taraval. They also offered ski equipment rentals in winter—very popular.

Fox Hostess House, 34th and Balboa—Operated by Flora Fox from the late 1940s until the early 1970s. She was able to put on wedding receptions, family reunion parties—any type of gathering, including excellent catered food.

Frank's Floral Shop, 19th and Irving—Operated for more than fifty years by Frank and Gladys Korkmazian, who lived at 14th Avenue and Lincoln Way. Every high school guy in the late 1960s knew that Frank's had the best five-dollar orchid corsages for prom dates. It's still there under new ownership.

Gene's Richfield, 23rd and Vicente—Operated by Gene Winkelbauer, who lived on 21st near Vicente. This was Dad's favorite place to buy gas and yack with the owner and employees.

Gillon Lumber Company, 4th and Geary—Founded by Edward Gillon in 1896, it was one of the first Richmond District businesses. Gillon, who lived nearby, ran it until his death in 1934, when it was taken over by Robert Byard, who operated it for the next forty-seven years. In 1981, his grandson Brandon Smith took over until 1992. The final owners were Sophia Abuda and her family, who closed the business in 2002, citing the usual problems of discount stores, changing customer base and difficult parking. Gillon outlasted its Sunset competitors, including White Lumber Company at 22nd and Noriega (closed early 1980s) and Koenig Lumber at 22nd and Judah (closed early 1990s).

Golden Brown Bakery, 21st and Irving—Operated by Wendel Kretz, who lived on Head Street in Ocean View. I can still smell its coffee cakes coming out of the oven, with that seductive brown sugar/almond paste aroma.

Herb's Delicatessen, Taraval near 32nd Avenue—Operated by Herb Thompson, who lived at 37th and Taraval. It was famous for meatball sandwiches created by Herb's wife, Jennie. The faded sign and shuttered storefront remain, a full fifteen years after new owner Issa Cuadra was evicted to make way for still-unbuilt condos.

Hot House, 750 Great Highway—Mexican restaurant extraordinaire operated by Barney Gavello, who lived on O'Shaughnessey Boulevard. Closed in 1972 when Playland died; it was resurrected on outer Balboa Street from 1972 to 1986 by new owner Juan Faranda, who took over from Gavello in the late 1960s, but now it's just a faded memory of convivial crowds, spicy aromas and cool salt air. In a bit of good news, though, Eric Faranda, son of the owner, is now catering his father's specialties throughout the Bay Area and is making plans to reopen the restaurant in a new location.

Joe's Ice Cream, 5351 Geary—Operated by Mike and Ida Baum, who lived on 22nd Avenue near Quintara. It seems as though there really were more ice cream stores in the Avenues back then than now.

HERB

MEATBALL SANDWICHES
EVERY THURSDAY

Herb's Deli on Taraval sold enormous homemade hot meatball sandwiches every Thursday from the early 1950s to 1998. *Author's collection.*

K&E FIVE AND TEN, 2226 Taraval—Operated by Mr. Karp, who lived in Lakeshore. This store had everything, from penny candy to Matchbox cars (remember those?), Halloween costumes, Christmas lights, binder paper and gym sox.

KIESER'S, Irving Street near 19th Avenue—Operated by Ellen Kieser, second-generation owner, who lived in St. Francis Wood. The diner was known for homemade ice cream and a jar of fresh strawberry jam on each table at breakfast.

LARRABURU BAKERY, 3rd Avenue near Clement—Operated by Harold Paul, who lived on 20th Avenue between Cabrillo and Fulton. This was every San Franciscan's favorite sourdough bakery for generations.

LITTLE DUTCH LAUNDROMAT, 39th and Taraval—Operated by Howard and Bessie Plank, my 18th Avenue neighbors. It was a self-service, coin-operated laundry, but both owners spent hours there daily, providing customer service.

O'CALLAGHAN REAL ESTATE/INSURANCE, 17th and Taraval—Longtime neighborhood firm that vied for decades with John Barbagelata and James Sullivan on West Portal and Julius Saxe on Noriega for property listings and sales. Four of Charles and Peggy O'Callaghan's granddaughters joined the ranks of the San Francisco Police Department, with one rising to the rank of deputy chief prior to her 2010 retirement.

OVERLAND PHARMACY, 21st and Taraval—Operated by Theresa Corsiglia, who lived on Magellan Avenue. Her late husband, Charles, started the business, and she kept it running for decades.

PARKSIDE BARBERSHOP, 951 Taraval Street—Operated by William Zoerb, who lived at 44th and Taraval. I had my first haircut there, staring into the mirrored wall in front of me that reflected the mirrored wall behind me—infinity. Bill handed out Tootsie Rolls and sometimes let young customers help wind up the revolving barber pole.

PING'S HAND LAUNDRY, 1111 Taraval Street—Operated by Yow Fong Yee, who lived on 33rd Avenue in the Richmond. In the 1970s and 1980s, I was a third-generation customer, bringing my dress shirts to this third-generation business.

POLLY ANN ICE CREAM, 3142 Noriega, near 39th Avenue—Operated by Charles and Bernice Lassiter, who lived just a few blocks away on 39th Avenue. It's now located at the corner of 40th and Noriega under new owners.

PORTALS TAVERN, 179 West Portal Avenue—Operated by University of San Francisco alums John Bosque, who lived at 23rd and Ulloa, and Joe Vollert of Parkmerced, always with a loyal collegiate following. It's still there under new owners.

ROAD TO MANDALAY, 314 West Portal Avenue—Operated by Jim Raven, who lived near Mount Davidson. From 1940 to 1961, this bar resembled a classic ocean liner beached on West Portal.

ROBERT'S CAKES AND PASTRY, 15th Avenue and Irving Street—Operated by Robert Hoffman, who lived at 25th and Kirkham. Great cakes and Danish. A Sunset District twin of Wirth Brothers.

SAVANO LUGGAGE, 320 West Portal Avenue—Operated by Sam and Carmela Savano, who lived nearby on Vicente.

SEA BEE LIQUORS, 40th and Taraval—Operated by Henry and Bernice Gerland, my 22nd and Pacheco neighbors. Under the Gerlands' watchful eyes, it was one of the few outer Taraval liquor stores that *never* sold to anyone underage—the Gerlands had teens of their own. Still there after many new owners.

SEABRIGHT MARKET, 1735 Noriega Street—Operated by Manny Maniates, who lived at 21st and Kirkham. Great neighborhood grocery that closed as Safeway expanded.

SISKIN'S THRIFT DRUGS, 9 West Portal Avenue—Owned by William Siskin, who lived in Lakeshore. Adjacent to the Twin Peaks Tunnel, it was the ultimate in convenience.

STAR PHOTO, 616 Irving Street—Operated by Walter and Suzanne Crick, who lived on 23rd Avenue near Moraga. A popular place when families had to "drop off the film for processing" and "wait for the prints to come back."

SUGAR BOWL BAKERY, 3640 Balboa Street—Owned by Mr. and Mrs. Harter, who lived on Shore View Avenue in the outer Richmond. Adjacent to the Balboa Theater, the name and logo live on via a company that distributes packages of incredible brownie bites.

SULLIVAN'S REAL ESTATE/INSURANCE, 31 West Portal Avenue—Owned by Supervisor James Sullivan, who lived on 17th Avenue near Ulloa, managed

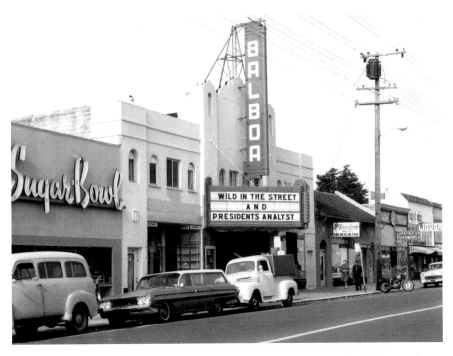

A row of businesses along Balboa Street near 37th Avenue in the late 1960s, including the Sugar Bowl Bakery and the Balboa Theatre. *Jack Tillmany Collection.*

by his assistant, Theresa Hession, who lived at 18th and Santiago. Sullivan's Cairn terrier, Tippy, had the run of the office. After Sullivan's death in 1961, Theresa took over the insurance business and ran it from her home office for more than twenty-five years.

TENNESSEE GRILL, Taraval near 22nd Avenue—Owned by Bill Whatley, who lived near Alemany Boulevard. This was our family's early breakfast spot when leaving on vacation. The hash browns are still sizzling under new owners.

VICENTE BEAUTY SALON, 1127 Vicente—Operated by Emily Nelisse, who lived upstairs with her children. Mom was a regular in the 1950s and again from 1970 until 2002 under new owner Kisae Woo. With the passing of so many ladies of Mom's generation, Kay retired, closing the business.

VICENTE BEGONIA GARDENS, 1100 Vicente—Operated by Ray and Madeline Anderson, who lived at 34th and Ulloa. The tiny store, angled at the northwest corner of 23rd and Vicente, dispensed supplies, plants and good advice for years.

VICENTE VARIETY, 1185 Vicente—Operated by Walter and Thelma Zorn, who lived at 19th and Ortega. I can still see Mrs. Zorn, seated at the front counter near the door, an old-fashioned wall phone alongside, surrounded by candy (so many choices): Tootsie Rolls/Tootsie Roll Pops, Jujubes, Good and Plenty, Hot Tamales, Red Vines, Jawbreakers, Necco Wafers, M&M's (Plain/Peanut), All-Day Suckers in cherry or grape, gum (Bazooka, Juicy Fruit, Doublemint, Chicklets, Dentyne, Wrigley's Spearmint, Black Jack), Hershey Bars (with/without almonds), Nestle's Crunch, Oh Henry!, Baby Ruth, Almond Joy, Mounds, Milky Way, 3 Musketeers, Snickers, Annabel's Rocky Road, Bonomo's Turkish Taffy, Life Savers (classic "5 Flavor" rolls and others), Sugar Babies, Sugar Daddys, Starburst, Red Hots, Dots, Junior Mints, Milk Duds, Bit-O-Honey, Sweetarts, Sourballs—oh, and remember candy cigarettes?

VOGUE REWEAVING STUDIO, 1143 Taraval—Operated by Mrs. Frances Fujikawa, who lived on Holloway Avenue in OMI. The ladies here could magically repair anything—tablecloths, jackets, pants, woolen scarves—with no sign of the mend.

WEST PORTAL JOE'S, 1 West Portal Avenue—Operated by Jorge Vargas, who lived at 27th and Lincoln. "Eat here and save a trip to North Beach" was the motto displayed on the sign. This was a wonderfully fragrant restaurant in an excellent location with plenty of easy parking. Sadly, it is long gone. Replacement restaurants have filled the spot, but the building was destroyed in a recent fire. A new restaurant is now under construction at the site.

WEST PORTAL PET SHOP, 44 West Portal Avenue—Operated by Anna Potter, who lived on Forest Side Avenue. There was always a green parrot out front and puppies scampering on shredded newspaper in the window.

WHITE LUMBER COMPANY, 1500 Noriega—Operated by Charles White, who lived at 22nd Avenue and Lawton. Convenient one-stop hardware/lumber shopping for do-it-yourselfers. I was a regular when I bought my first house on 22nd Avenue near Pacheco in 1979.

WIRTH BROTHERS PASTRY SHOP, 5901 Geary at 23rd Avenue—Operated in the 1950s by Anthony and Elizabeth Wirth, who lived at 26th and Kirkham. Great coffee cakes and Danish pastries. It reopened briefly by new owners with the original recipes, circa 2001–2.

Chapter 9

PARKS AND PLAYGROUNDS AND CIRCLES AND SQUARES

G rowing up in the Parkside in the 1950s and 1960s usually meant playing in the street on our almost-cul-de-sac block of 18th Avenue. Traffic was very light, there were few parked cars to get in the way and street games could go on uninterrupted for long periods of time—or at least until the street lights came on. St. Cecilia's schoolyard, just a half block away, also received regular use after school and on weekends. As we grew older, however, we began to discover the wide variety of public parks and playgrounds, circles and squares that still dot the entire neighborhood. Here's a brief look back at several that I remember the most.

GOLDEN GATE PARK. My earliest memories of Golden Gate Park go back to about 1953 or so and the live Nativity scene that was on display each December in one of the meadows. Mom and Dad and I would be bundled up against the cold, and we'd watch the actors and the animals in amazement. I once declared that I wanted to be a shepherd when I grew up, since it seemed like a lot of fun to carry a long pole and chase after the sheep. We spent many a weekend afternoon on the swings and slides at the Children's Playground, watching the bison in the Buffalo Paddock and visiting the Band Shell and the Japanese Tea Garden, plus the two windmills and the tulip garden at the far western end of the Park near Ocean Beach.

Later, in the 1960s, came the rosary crusade at the Polo Field, concerts in the Panhandle and museum visits to learn about the treasures of the De Young Museum and exhibits at the Academy of Sciences (then known as the Steinhart Aquarium and the Morrison Planetarium).

Above: The Children's Playground in Golden Gate Park, shown here in 1978, has been delighting youngsters for more than one hundred years. *Mary Anne Kramer photo.*

Opposite, top: This navy jet was a popular Larsen Park attraction at 19th Avenue and Vicente in the early 1960s. Gone for decades, the city is now working to acquire a replacement. *Richard Lim photo.*

Opposite, bottom: No matter how many parks and playgrounds are nearby, the best place to play has always been right in front of your own home, 18th and Irving, 1963. *Rex Bell photo.*

The park was also one of Dad's favorite places to take young drivers for practice time. It seems that we drove endlessly, back and forth, from the Panhandle to the Great Highway—probably the longest stretch of San Francisco roadway uninterrupted by stop signs or traffic lights back in those days. Dad taught a dozen or more of the kids in our neighborhood to drive, and he was remarkably even-tempered with all of us. Having worked with Mom and her sister when they were learning to drive in the late 1950s, my father was capable of miracles, and many neighborhood parents were eternally grateful that he was able to help them deal with this teenage rite of passage. To this day, when I'm on Kennedy Drive, I can still hear him saying,

in between his puffs on his Kool menthols, "Okay, now just hold it nice and steady at twenty-five miles per hour until we get to Playland, then we can turn around and drive all the way back to Kezar the same way."

My bookcase still contains photographic evidence showing our entire 234-member St. Ignatius (S.I.) senior class hoisting a few beers—Olympia seems to have been the brand of choice back then—on Strawberry Hill one night in May 1970, just before graduation. I guess that I should not dwell on this enjoyable outing too much, however, lest today's school rules be invoked retroactively and cause me to lose my membership in the Alumni Association.

Larsen Park. We all grew up hearing about the generosity of old Carl Larsen, who donated two full blocks of land to the city for recreational purposes. His gift is memorialized by an enormous rock with a metal plaque at the corner of 19th Avenue and Ulloa Street, at the northeastern tip of the park near the baseball diamond.

The swings and slides at the corner of 19th Avenue and Vicente Street were visited regularly when Mom and I used to take our weekly walks to Taraval Street in the early 1950s, and Dad and I used to walk down there on Sunday mornings when I was four or five to play what was loosely called "tennis"—there were never enough adults waiting that a pre-schooler and his Dad couldn't be there, just hitting a ball back and forth.

The addition of decommissioned jet fighter planes in the southernmost part of the park just across Vicente Street (a navy blue model installed circa 1959 or so and an updated gray version in about 1972) made a good playground even better. Although the park has been "plane-less" for several decades, there is now a renewed drive underway to have a replacement installed.

There was great neighborhood excitement when the adjacent pool was built in the late 1950s, as well as much surprise and consternation when it had to be torn down and replaced less than fifty years later.

Larsen Park was also the favored neighborhood spot for spring kite flying—no overhead power lines—and passing motorists often saw groups of happy kids at play. Students in the upper grades of nearby St. Cecilia School were taken to the park for noon break in those years, and it was there that so many of us found ourselves trying to rationalize what had just happened in Dallas, Texas, on that dark November day in 1963. The large tree, just north of the tennis courts, also marks the final resting place for a couple of beloved 1960s neighborhood pets.

Each time that I drive past there, I'm reminded of a warm spring Friday night in 1970 when a group of seniors and their friends from Mercy, Presentation and St. Rose got into an enormous food fight at the site of

the jet, in which the only weapons were several boxes of Screaming Yellow Zonkers—a Cracker Jack-like sugar-coated popcorn snack. Even though it was all good, clean fun, one of the neighbors (a crotchety, quarrelsome old fifty-plus person, like we all are today) called the police, who laughed hysterically when they arrived in two squad cars, red lights flashing. As they walked across the sand, their spotlights caught sight of the girl from Pres, whose long, dark Ali MacGraw–style hair was covered with the sticky snack. Face it, when the cops arrive laughing, you know that you're home free. So long ago…so far away.

McCoppin Square. Another full two city blocks, stretching from Santiago to Taraval and from 22nd to 24th Avenues. Although the Parkside Library was a frequent destination for everyone in the neighborhood, there seemed to be an unwritten rule that the area behind the library building's patio was exclusively Lincoln High School territory. Judging from appearances, the area was a secluded drinking and smoking lounge for many teens, and many Sunset District parents did not like their kids hanging out there. A late 1960s shooting in the square solidified their resolve that, except for the library itself, the entire area surrounding the Lincoln campus should be off-limits to their teenagers, unless they were students there.

Mountain Lake Park. Spanish explorer Juan Bautista de Anza stopped at this site in 1776, when he selected the site for the Presidio of San Francisco. In 1875, the park was developed by renowned landscape architect Frederick Law Olmsted. In addition to a playground and tennis courts, one San Francisco's first fitness courses was developed here in 1980. A local neighborhood volunteer group works with the city's Recreation and Parks Department to maintain the area.

Palace of the Legion of Honor Parking Lot. This was the "new" make out/drinking spot for the Western Neighborhoods in 1970, once the police cracked down on the activities taking place at the end of Sunset Boulevard. Richmond District teens resented the influx of Sunseters, since their once-quiet and relatively private spot for watching the submarine races was quickly becoming too crowded for comfort. Surprisingly, the SFPD never bothered anyone in this location for the remainder of that school year—did they not know, or did they just think that this new spot was an improvement over the old?

Parkside Square. At 26th and Vicente, nestled up against the eucalyptus woodiness of Sigmund Stern Grove, Parkside Square has long been established, with basketball and tennis courts, plus baseball diamonds, one of which honors longtime athletic director Bob Chaney. Stretching along

SUMMER CONCERT SERIES

Above: Large numbers of school-age children in the Western Neighborhoods ensured that there were always playmates nearby, 43rd and Balboa, 1957. *Paul Judge photo.*

Left: Free Sunday afternoon summer concerts have been a feature of Sigmund Stern Grove (logo seen here) since 1938. *Author's collection.*

Vicente, it remains the perfect neighborhood spot for competitive sports, dog walking or relaxation on a shady bench on a warm, Indian summer afternoon. Similar to Larsen Park several blocks away, Parkside Square has long been the agreed-on meeting point for many families in the event of a natural disaster.

Rossi Playground. Developed on the site of one of the old Odd Fellows' Cemeteries, the playground was opened in the 1940s and has been recently renovated to accommodate the play needs of both younger and older children. With adjacent baseball facilities, an indoor swimming pool, dog-friendly areas and many benches, it remains a delightful urban oasis on Arguello Boulevard in the Richmond District.

Sigmund Stern Grove. Everyone knows about the summer concert series that has been held at Stern Grove since the 1930s. Living nearby, though, many of us locals never attended one—at least, not until July 1969, when our parents, like most Americans, were overjoyed with the first moon landing by American astronauts. We teenagers, however, having grown up with a steady diet of space exploration on television, didn't think that this was any big thing and were profoundly bored by all the hoopla surrounding the "big day." As a result, the Stern Grove concert of July 20, 1969, had one of its biggest crowds ever—mostly people under the age of twenty-five. In retrospect, it was something of a West Coast mini-precursor to Woodstock, which occurred just one month later—although we were all on our way home after just a few hours when the fog began to roll in.

The Circle. Although the intersection of Santa Ana Way and St. Francis has the official designation of "The Circle," everyone growing up West of Twin Peaks knew that the name applied, unofficially, to the large paved area at the intersection of Sunset and Lake Merced Boulevards. Our parents knew it as the place where young drivers could navigate safely and practice their parallel parking under adult supervision, with little threat of an accident. All of us, however, knew it as a place to practice various other maneuvers associated with parking. In about January 1970, my senior year at S.I., officers at the San Francisco Police Department's Taraval Station on 24th Avenue finally realized what was going on out there on the shores of Lake Merced and initiated a huge crackdown one Friday night. Lots of embarrassed couples hastily buttoning things up, tires squealing to escape the onslaught of flashing red lights and several hundred beer cans tossed into the lake made for some neighborhood excitement. The slow-footed and the fumble-fingered were detained, questioned and asked to show their driver's licenses, while those with flashy-looking cars were also asked to produce registrations. Meanwhile, a few parents received the dreaded call from SFPD to come and pick up their child. The Circle went silent for the remainder of that school year, as romantic and alcoholic pursuits were quickly and quietly relocated to the parking lot of the Palace of the Legion of Honor, which was under the jurisdiction of the police at Richmond

Golden Gate Park Music Concourse in 2009, with the new California Academy of Sciences on the far side and UC Medical Center in the distance. *Nestor Nuñez, Broken Sphere photo.*

station instead of Taraval station, thus ensuring that revelers were able to party uninterrupted once again.

WEST SUNSET PLAYGROUND. During April of my senior year at S.I. on 37th Avenue, a small group of us realized that while we had supported every school event for four years—football and basketball games, tennis matches, swimming and track meets, plays and musicals, band concerts, dances and debates—we had never been to an S.I. baseball game. Off we trooped to the top row of seats at West Sunset in order to place a mental check mark on yet another high school activity, just six weeks prior to graduation. It was to be one of the last group adventures for many of us, for once we graduated in early June, we went our separate ways; many of us have not crossed paths since. Yet every time I drive along near there, I recall the shared hopes and dreams of a group of eighteen-year-old kids who were perched high up in those stands, laughing and cheering that afternoon, while being buffeted by the strong incoming ocean breezes that were set to take us far from that baseball field at 41st and Ortega to distant places across the globe.

Thinking back, I remember how Grandma used to smile at her own memories of Golden Gate Park in pre-earthquake San Francisco whenever we drove past the Conservatory of Flowers. I'm sure that she still recalled the *clop-clop* of horses' hooves, the crack of the reins and the bounce of a carriage on a pleasant day, as she remembered her own childhood experiences in the 1880s. Fast-forward to the fall of 2009, when I visited the new Academy of Sciences with a brother and sister I had grown up with in the Parkside. At one point, a family asked us in somewhat fractured English if we would take a picture of them with their camera. As I focused on the parents and the small boy and girl holding hands tightly, the leafy green beauty of the trees in the Music Concourse and the angular forms of the new De Young Museum filled the background. As I snapped the shutter, I knew that this scene would one day form someone else's fond recollection of "when we were young in San Francisco," and my friends and I were pleased to be a small part of their happy memories.

The following is a more complete listing of city parks located in the Western Neighborhoods:

Aptos Park
Aptos Playground
Argonne Community Garden
Argonne Playground
Baden and Joost Mini-Park
Balboa Natural Area
Balboa Park
Bengal Alley
Berkeley Way Open Space
Brooks Park
Brotherhood and Chester
 Mini-Park
Brotherhood Way Open Space
Cabrillo Playground
China Beach Park
Christopher Playground
Crag Court Garden
Crissy Field
Edgehill Mountain
Erskine (Dorothy W.) Park
Fulton Playground

Garden for the Environment
Glen Canyon Park
Golden Gate Heights Park
Golden Gate National
 Recreation Area
Golden Gate Park
Grand View Park
Hawk Hill Park
Kahn (Julius) Park
Lake Merced Park
Land's End
Larsen Park
Laurel Hill Playground
Leff (Muriel) Mini-Park
Lower Great Highway Park
McAteer (Frances) Tennis Courts
McCoppin Square
Merced Heights Park
Midtown Terrace Playground
Miraloma Park
Mountain Lake Park

Mount Davidson Park
Mount Sutro Open Space Reserve
Murphy (J.P.) Playground
Nicol (Rolph) Playground
Ocean Beach
O'Shaughnessy Hollow
Palace of the Legion of Honor
Pine Lake Park
Presidio
Randolph and Bright Mini-Park
Richmond Playground
Rochambeau Playground
Rocky Outcrop Park
Rossi Playground
Serra (Junipero) Playground
Sigmund Stern Grove

Sloat and Junipero Serra Open Space
South Sunset Playground
Stanford Heights Reservoir
Sunnyside Conservatory
Sunnyside Playground
Sunset Recreation Center
Sunset Reservoir
Sutro Heights Park
Tank Hill Park
Topaz Open Space
Ward (Minnie and Lovie) Recreation
 Center
West Portal Playground
West Sunset Playground
White Crane Springs
 Community Garden

A New Phenomenon: Parklets

Decades ago, San Francisco tried, with mixed success, to build "mini-parks" on empty vacant lots throughout the city. Now, in the second decade of the new millennium, there has been incredible success with a new concept: the parklet. By bumping out the sidewalk and taking over as few as just two parking spaces in a neighborhood business district (particularly in areas adjacent to bakeries, delis, restaurants and coffee houses), a small area with planters and benches for a dozen or so people can be created for public use. This benefits pedestrians, nearby merchants and the neighborhood overall, as residents have a new place to sit and relax. In addition, when located near a busy corner, the bump-outs shorten the distance that pedestrians must walk when crossing a busy thoroughfare. The first few parklets have been located on Balboa and Clement in the Richmond District, as well as along Judah, Noriega and Taraval in the Sunset District. Everyone seems to be giving these new spaces a big *thumbs up*!

Chapter 10

A NIGHT AT THE MOVIES

If ever there was an endangered species in San Francisco (in addition to born-and-raised residents), it is the neighborhood movie theatre. At one time, such businesses were the very heartbeat of every residential shopping area, but the post–World War II era marked the beginning of the end for many of them.

ALEXANDRIA, Corner 18th Avenue and Geary Boulevard—Opened in 1923 with then-trendy Egyptian décor, this large place was remodeled in Art Moderne style just before the outbreak of World War II. It was home to a year-long engagement of *South Pacific* in the late 1950s, plus long-running showings of *Cleopatra* and also *Oliver!* in the 1960s. In 1976, the declining trend in attendance caused the Alexandria to be cut into three separate auditoriums—balcony, loge and main floor. It closed more than ten years ago, in February 2004, and there has been considerable ongoing discussion about possible future uses for the site, including a restaurant and a small theatre in the old building itself, with three-story apartment/condo units to be constructed on the rear parking lot that faces onto 18th Avenue.

BALBOA, Balboa Street, between 37th and 38th Avenues—Opened in 1926 and converted to twin screens in the 1970s, the Balboa is a true survivor. From the silent era to the talkies to new programs several times a week, the Balboa has long catered to the preferences of its audiences. In the 1960s, it became home to extended "second-run" neighborhood showings of such blockbusters as *The Sound of Music* (five full months in 1966–67) and *Dr. Zhivago* (seven full months in 1967). After splitting into twin screens in 1978, the Balboa now offers quality second-run double-features to appreciative audiences.

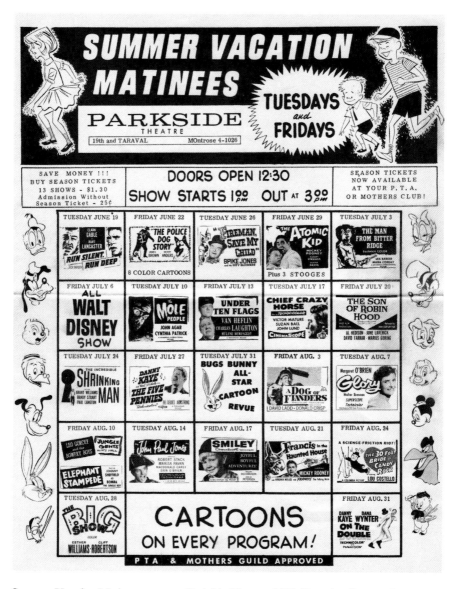

Summer Vacation Matinee program, Parkside Theatre, 1962. Note that "season tickets" included thirteen shows for just $1.30! *Joseph McInerney Collection.*

BRIDGE, Geary Boulevard, between Blake and Cook Streets—Named for the recently opened Golden Gate Bridge when it was built in 1939, the Bridge was a second-run house until the 1950s, when it began to feature international films. In the 1960s, it was home to long runs of both *Zorba*

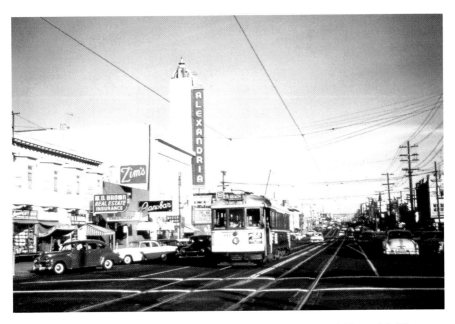

B-line streetcar on Geary at 19th Avenue, with Zim's Hamburgers and Alexandria Theatre in background, 1956. *Jack Tillmany Collection.*

the Greek in 1965 and also *Georgy Girl* in 1966–67. It went dark in December 2012 and is now reported to be under renovation as the new home of a local baseball training school.

CHUTES, Fulton Street, between 10th and 11th Avenues—Once a part of the "Beer-Town" recreation area opposite Golden Gate Park, it is unlikely that any readers will have firsthand knowledge of this place. Opened in 1902, it was gone by 1909.

COLISEUM, Corner 9th Avenue and Clement Street—Opened just days after the end of World War I in 1918, it boasted one of the largest seating capacities in the Richmond District, with more than two thousand seats. Originally playing silent films, it made the transition to talkies and was within easy walking distance of thousands of new households in its early years. It was suffering the usual woes of declining attendance when it became a casualty of the 1989 Loma Prieta earthquake and was never able to reopen. The building's façade was preserved, and the site has now been converted into condominiums, with ground-floor retail space.

CORONET, Geary Boulevard, near Arguello Boulevard—One of San Francisco's more modern theatres, it was opened in 1949 as a second-run neighborhood house. By 1956, it was converted to first-run with reserved

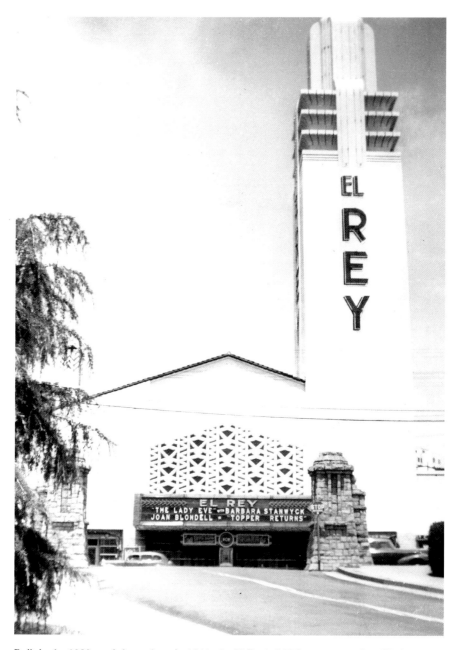

Built in the 1930s and shown here in 1941, the El Rey's 1,750 seats were often filled to capacity until the 1960s. Closed in 1977, the site has since been the Voice of Pentecost Church. *Jack Tillmany Collection.*

seating and was home to long-running hits such as *Oklahoma!, Around the World in 80 Days, Ben Hur* and *Funny Girl* in the 1950s and 1960s. And who doesn't remember standing in line for *Star Wars* in 1977? The Coronet closed in 2005, and the building was demolished. The site is now a 150-unit subsidized senior housing complex.

EL REY, Ocean Avenue, between Fairfield Way and Lakewood Avenue—From the time that it opened in 1931, the El Rey was one of the largest neighborhood theatres, with 1,750 seats. It fell victim to declining attendance and closed in 1977, when it became the Voice of Pentecost church.

EMPIRE, West Portal Avenue, near Vicente Street—Opened in 1925 as the West Portal, it became the Empire in 1936. By 1974, it had been split into three auditoriums, and the author clearly remembers trying to watch *Love Story* in one of the smaller theatres as the North African gunfire of *Patton* was blazing away on the opposite site of a too-thin wall. Today, it's the Cinearts at the Empire, featuring independent films.

FOUR STAR, 23rd Avenue and Clement Street—Originally the La Bonita when it opened in 1913, it morphed into the Star in 1927 and into the Four Star in 1946. Tiny even by neighborhood standards, it closed in 1990 but was reopened in 1992, featuring films from Hong Kong. A second screen was added in 1996, and the theatre advertises itself as showing alternative cinema from around the world, as well as new Asian films on a regular basis.

IRVING, Irving Street, between 14th and 15th Avenues—With a grand sign and Spanish/Moorish-inspired archways towering above a neighborhood shopping street, the Irving opened in 1926. Mostly a second- and third-run house with kiddie cartoons, the Irving holds the distinction of being one of the area's shortest-lived theatres; it closed in 1962. It was soon demolished, and the site is now occupied by apartments.

NORIEGA, southwest corner 25th Avenue and Noriega Street—This was never built. When home builders Costello, Doelger and others were constructing block after block of Sunset District homes in the 1930 and 1940s, land was set aside for a neighborhood theatre. World War II intervened, and after 1946, there was a renewed emphasis on housing for returning GIs and their families, and so the vacant "theatre" lot remains today.

PARKSIDE, Taraval Street, between 19th and 20th Avenues—Built in 1928 and given a facelift in the 1930s, the Parkside was my local hangout growing up in the 1950s and 1960s. Another major remodel in 1965 rebranded the place the Fox Parkside (minus the iconic red neon sign), but audiences were dwindling, and the place was closed in 1988. It is now a private preschool/ day-care center with the iconic name Parkside School.

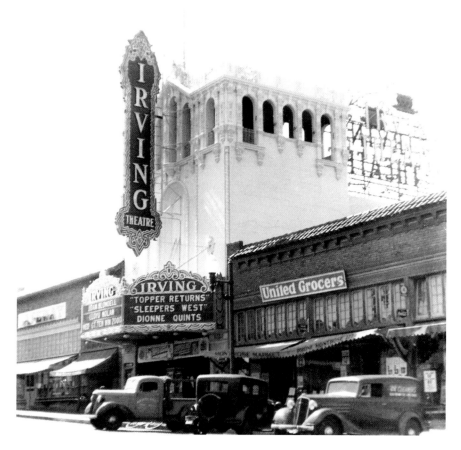

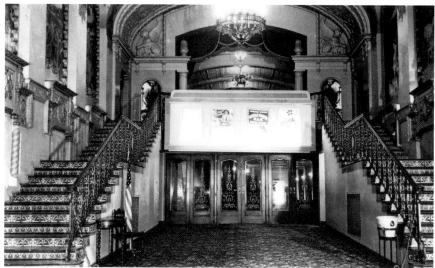

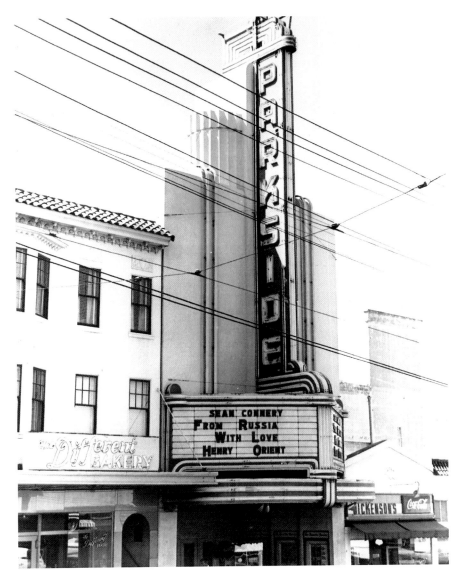

Above: The soft red glow of the Parkside's large neon sign, shown here in 1964, lit up the foggy nights for blocks around. *Jack Tillmany Collection.*

Opposite, top: The Irving Theatre, shown here in 1941, was built in 1926. It was among the first neighborhood houses to close due to declining attendance, 1962. *Jack Tillmany Collection.*

Opposite, bottom: The Irving's ornate lobby and double staircases with colorful ceramic tile risers were typical features of 1920s theatres. *Jack Tillmany Collection.*

PRESIDIO, Moraga Street, Presidio of San Francisco—Not to be confused with the Chestnut Street theatre of the same name, this building is tucked away in the Presidio of San Francisco and was built by the WPA in the late 1930s. After providing decades of film entertainment to military personnel, the building became surplus as the former military post surrounding it was decommissioned in the late 1980s when Congress eliminated the Presidio as an active military installation. The entire base was transferred to the National Park Service for mixed commercial and public uses in 1994. The theatre building remains available but is regarded as something of a white elephant due to its remote location.

SURF, Irving Street, near 45th Avenue—Constructed as the Parkview in 1926 and renamed the Sunset in 1937, the small house became the Surf in 1957. For most of its remaining years, it featured classic older films and a devoted audience. The author saw *Citizen Kane* here several times in the early 1970s. The theatre was closed in 1985 and has since housed a small neighborhood church.

UA STONESTOWN, Buckingham Way, west of 20th Avenue—Constructed in 1970 as a single screen, it opened in the fall of that year with the Barbra Streisand/George Segal comedy *The Owl and the Pussycat*. The large auditorium was divided into two theatres a few years later, although the seats were not repositioned at the time. As a result, viewers seated on the right-hand side of the auditorium located on the left found themselves angled slightly toward the middle wall, as did the viewers seated on the left-hand side of the auditorium located on the right. One of the saving graces here is the ample free parking that surrounds the building, which is adjacent to the Stonestown Galleria shopping center.

WESTWOOD, Ocean Avenue near Faxon Avenue—Opened in 1922 as a venue for silent films, it was originally the Balboa, until a new Richmond District theatre took that name in 1926, at which time this site became the Westwood. It survived only a few years and was closed when the much larger and more elaborate El Rey opened just a block away in 1931. The building was demolished for a grocery store, which has now become yet another chain pharmacy.

Television, tapes and DVDs, plus video streaming, have all contributed to the decline of neighborhood theatres across the country. In spite of today's improved technology and downright convenience, though, the experience has never been quite the same as on those long-ago Saturdays, sharing popcorn while seated snugly in the loge section.

Chapter 11

OUT ON THE BACK FORTY FEET

Many of the houses that were built in the Outside Lands followed a simple format of 25-foot-wide lots. Throughout most of the area, these lots were generally 100 to 120 feet deep—roughly 60 or so feet of house and 40 to 60 feet of backyard. Given those 25-foot widths, most of us grew up in houses that were just a little over 1,000 square feet—tiny by comparison to many of today's new homes. Yet even within these simple parameters, owners constructed a huge variety of landscapes. Today, many backyards are neglected and ignored, but in the mid-twentieth century, things were very different.

Much of the original landscaping installed years ago by the builders and the original owners flourished because those folks knew what would survive in the sandy soil and foggy climate. When my parents bought their home on 18th Avenue back in 1948 (for the then-outrageously high price of $13,000), the original owners had a magnificent center area planted in rosebushes—all hardy varieties that were fragrant and that produced magnificent blossoms. Beginning in the early 1950s, my parents added a small square of lawn, primarily as a play location for kids. To this day, neighborhood backyards without some trace or history of a lawn were invariably owned by folks with no children, since everyone else had the requisite square of grass. Those rosebushes, however, are still there, producing an annual color spectacle from early spring through late fall, many decades after they were first planted.

One next-door neighbor had a swing set in the rear portion of the backyard when their first child was born in the 1930s, and over the next

Backyards offered a sunny spot for family photos, 19th and Quintara, 1958. *Jo Anne Quinn photo.*

fifty years, it stood as silent testimony to the fact that there were once many youngsters in that house. Gradually, over the decades, the canvas seats and metal chains began to corrode and disappear, and by the time I was small, they had vanished completely. The big A-shaped iron frame remained intact and soon became a trellis for a variety of plants and vines, but by the mid-1980s, it, too, had succumbed to nature and had completely corroded back into the ground, where the iron-rich soil produced magnificent hydrangeas of every color—another plant well suited to the climate of the Western Neighborhoods.

Sometimes there was just work to be done, 22nd and Moraga, 1954. *John Paul Sant photo.*

Our other next-door neighbor started a vegetable garden during World War II and continued to maintain it with her favorite artichoke plants—another sturdy species for the area. Those plants produced bushels full of crop each season, and it's little wonder that artichokes were a regular vegetable on our dinner table, as Mrs. Vincent often gave Mom some of her surplus output.

In a city where Catholics were once well over 50 percent of the population, there are likely still numerous shrines or grottoes to the Blessed Mother tucked away in corners of backyards. These will invariably have a baby rose bush

growing somewhere nearby, whose flowers were used in May processions at St. Gabriel, St. Cecilia, Holy Name or St. Anne. These families invariably took First Communion pictures in their "grottos."

Catholicism probably also contributed to the large number of "pet cemeteries" in Sunset District backyards. I personally attended many graveside services in my younger days, in which the deceased had an appropriate and heartfelt farewell in a green Stride-Rite shoebox or a White Owl cigar box, adorned with many flowers and a generous splash of holy water, with words recited from *My Sunday Missal*. Even as late as 1970, as a high school senior, I found myself pressed into service in the role of grave-digger at one such ceremony for a deceased rabbit named Howie at 27th and Noriega one foggy evening.

Camellias and rhododendrons were classic pairs of shrubs, one blooming in the winter and then fading as the other took over in the spring. Solid pink was the usual favored hue in the past, although nurseries have now expanded the color spectrum of both of these plants considerably.

Dahlias seemed to be everyone favorite plant in the 1960s, and they grew quickly, providing ample color, even in the foggy summertime. But their flowers could not be cut and enjoyed inside the house because of the strong odor.

Bulbs provide steady performance year after year, and many neighborhood backyards were planted with daffodils, tulips, fragrant freesias and miniature grape hyacinths that always signaled the start of spring. There were also the red and the orange gladiolus bulbs that returned to bloom faithfully, year after year, that were referred to by many of our neighbors as "those free bulbs from Clorox," referring to an early 1950s promotion by the bleach manufacturer.

Calla lilies were another abundant flower, well suited to the climate and also to the propensity of many families to visit cemeteries on weekends. Many of our neighbors also learned that calla lilies could absorb food coloring through their cut stems and become magically transformed for holidays— green for St. Patrick's Day, blue (combined with the standard white) for Passover and a variety of pastels for Easter.

Fences in most areas of the Sunset were wood, and these have always succumbed to the elements with a frustrating degree of regularity. On my old block of 18th Avenue, the builder wisely installed chain link cyclone fencing, and while not particularly attractive, it has stood the test of time, remaining intact for the nearly eighty-year life of the homes in the area. Generations of owners have obscured the harsh look with ivy, jasmine or other vines that

Backyards also offered play spaces for kids, pets and tents, 38th and Wawona, 1950. *Robert Menist photo.*

quickly loop through the links, providing a lush green wall of separation from the neighbors.

Today, far too many owners neglect their backyards and seldom venture out there. For all of us baby boomers, these places were yet another extension of the neighborhood. Kids sets up tents and built ramshackle forts out there. We had summer water fights, and we were all out in our yards on that snowy Sunday morning in January 1962, after decimating the snow on the front sidewalks and lawns. Throughout the 1960s and 1970s, high school graduation parties always spilled into the backyard, at least until the neighbors called to complain about hearing the rhythmic sounds of Simon and Garfunkel at one o'clock in the morning.

Many homes also contained a center or a side patio adjacent to the living and dining rooms. One neighbor was a fuchsia aficionado, and she got Mom hooked on the dozens and dozens of different varieties and colors of that plant. In the late 1950s and early 1960s, our center patio was a riot of colors from more than two dozen hanging redwood baskets with cascading fuchsias. The summertime fog was great for them, but warm days in the spring and fall required gentle hand-watering over the tops of the leaves and the flowers. The annual heat waves, usually a week in June and another

one in September (they always seemed to coincide with the start and the end of the school year), forced Mom into a watering frenzy. Pretty as they looked, though, they attracted every bumblebee in the area, and Dad quickly got tired of having to chase bees out of the kitchen; also, the dead flowers would invariably drop onto his carefully painted barn-red patio floor. In the end, Dad convinced Mom that he was tired of chasing bees and repainting the patio floor, so the fuchsias departed and were replaced with glass wind chimes and a single potted plant that changed with the seasons (poinsettia, Easter lily or chrysanthemum).

The backyard was also a popular designated "relocation point" in case of earthquake, and Mom and I spent many hours sitting there on that March day in 1957 when the region experienced a 5.3 earthquake—the most severe since the aftershocks of the 1906 whopper. When I went to check on her following the Loma Prieta quake in October 1989, there she was with her sister, the two of them listening intently to a transistor radio while seated on folding chairs on the lawn in her backyard, a good distance from the house, just as many of the neighbors were doing.

Our family knew that from the backyard, we could reach out to the folks on the next block—people we quickly came to know just as well as those on our own street. The new baby, new dog or new resident was always warmly welcomed over the back fence. Recipes were exchanged, inquiries were made about family members and everyone kept track of the childhood illnesses that occurred. A bedroom light burning late at night in a house that was usually dark was a sure sign that something was wrong, and Mom would quickly find out what was the matter, just by waving a friendly hello later in the week as the resident was out watering. The quiet intimacy of the backyard was sometimes more conducive to the exchange of personal confidences than the more public setting on the sidewalk in front of someone's home.

It was no wonder that in Mom's final days, as she approached ninety, she wanted to return home from the hospital to her own bedroom. There she could gaze out onto the flora and fauna that she had lovingly tended and watched for more than fifty years, including the large lilac tree that she and my father had planted in the early years of their marriage. Off in the quiet distance, she could detect the familiar sounds of friendly neighborhood dogs, the mirthful squeals of toddlers at play and the bubbling of one neighbor's recently installed hot tub. Above the rhythmic *swosh-swosh* of rotating lawn sprinklers, she could hear the distant roar of the lawnmower as the neighborhood's longtime and friendly landscaper worked his way up and down the block, house by house. Indeed, her last sensory perception of

this life must have been the fragrance of those many old rosebushes, drifting up to her open bedroom window on that extraordinarily warm August night when she left us in 2002.

Many new owners overlook backyards almost entirely, except to estimate just how far the law will allow the intrusion of new residential additions. For many of us, though, these outdoor places were magical, cherished parts of our lives growing up—every bit as important to our personal stories as the very homes in which we were raised.

Chapter 12

STOP, LOOK AND LISTEN

The *San Francisco Chronicle* reported recently that Commodore Sloat School has resurrected its School Safety Patrol, with Alice Fong Yu and Lakeshore Schools next in line. While there are now "paid adult supervisors"—don't ask me what that's all about—it's good to see that an important program has returned.

The School Safety Patrol was established in the 1920s by the American Automobile Association in response to a large number of vehicular accidents involving schoolchildren—generally reported in gruesome detail in the newspapers of the era.

In the past, most students longed for the job from an early age, and the mere threat of exclusion kept many of us in line during our formative years. In recent times, though, the concept of "drive-through" drop-off/pick-up became so commonplace that the program was dropped, thus denying many youngsters an important rite of passage.

Thinking back, most of us breezed through our first dozen years, facing only the challenges of getting out of bed, washing and dressing, scarfing breakfast and walking to school. Moms and Dads generally did all the heavy lifting, while most of us had relatively carefree childhoods. Along about sixth grade, however, we began taking on some real responsibilities that affected others—assignment as a traffic girl or boy.

Once selected, at about age twelve, we received on-the-job training from older students who were moving on. In addition to the task of looking out for others, we also learned how schools and workplaces transition over the

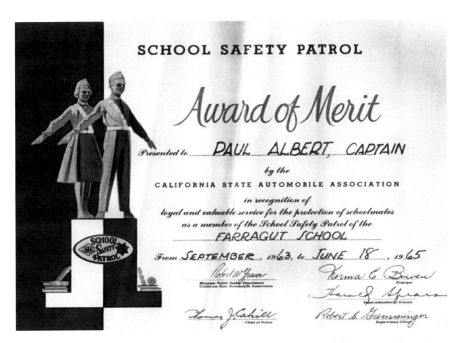

Many young people, boys and girls alike, had a real taste of responsibility as members of a School Safety Patrol. *Paul Albert Collection.*

years, with newcomers filling slots as more experienced people progressed into other activities.

Armed with a yellow-orange cap and a white canvas belt across the chest, the duties were straight-forward—standing at curbside, arm held out horizontally to keep the pedestrians out of the street, and looking both ways to ensure that there was no oncoming traffic. Then, turning and extending the arm ninety degrees, pedestrians would be allowed to cross safely.

There was a ritual to folding the belt and securing the hat within the folds to make a single package. We were told to keep these items clean, and some truly fastidious kids learned ironing at an early age to maintain a crisp image. Those assigned as sergeant, lieutenant or captain of the squad were also responsible for scheduling, plus filling in for absences. This was perfect training for many who later came to be responsible for staff coverage in high school organizations or at some future employer. Attending the annual review (at Golden Gate Park's Polo Field in 1964 for me) was a highlight of elementary school days.

Fond recollections spanning six decades have been posted on the Western Neighborhoods Project message boards in one of the longest-running

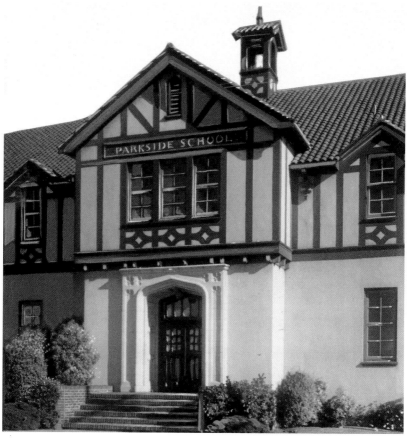

continuous threads, beginning more than eleven years ago. (See http://www.outsidelands.org/streetwise_stop_look_listen.php). While some recall the role as traffic *boy*, nearly one-third of the comments came from former traffic *girls* who served as far back as the 1950s in several local schools.

Many cited the benefit of learning the structure of an organization. Everyone recalled the annual assemblies, at Civic Center Plaza in the World War II era, later at Kezar Stadium and, for many years, at the Polo Field in Golden Gate Park. Another popular perk was free weekend movie passes to local theatres.

Many recalled that any youthful misbehavior in the lower grades usually produced a stern reminder that the perpetrator would never be allowed to join the squad in later years, thus bringing many disciplinary issues under control very quickly. *Everyone* wanted to join their school's squad—it was a mark of pride in those days.

One person summed up the situation at Commodore Sloat School at Ocean and Junipero Serra in the 1960s:

We each had our station as these were situated strategically around the school. The status spot was at Sloat and Ocean on the school side. The stations on Darien Way were too tame, and the southwest corner across from Bowerman's Drug Store was for the last kid picked to be on the traffic boy squad. It was the "right field" of traffic boy stations…Every so often the cop in charge of all traffic boys would come by, and we would salute. Heck, any cop that came by got a salute. In fact, we saluted anyone in uniform: the guy from the Water Department, the MUNI man of the month, the Tidewater gas station attendant…On rainy days we would get a few more minutes of freedom as we would have to go into the janitor's area located off the inner school yard to get into our bright yellow rain coats and black rubber buckle-up boots—I can only wonder what the girls were thinking as we boys were standing in the rain and fog as they got into warm cars to go home.

Opposite, top: Bowerman's, the store with the iconic "rings of Saturn" spire, shown here in the 1950s, was a fixture in the Ocean Avenue–Lakeside shopping area for decades. *WNP Collection.*

Opposite, bottom: Shown here in 1926, Parkside School boasted distinctive architecture but was closed in the 1970s and sat vacant for years before being demolished in 2004. A bland new school building now occupies the site. *Courtesy of San Francisco History Center, San Francisco Public Library.*

Another comment, from a woman who served almost fifty years ago, noted:

> *I was part of Traffic Duty in the 1960s at Parkside. It was thrilling when the police would drive by and salute you! We had what was called "12:30 duty" for the children coming back from lunch. At that time, the Zodiac killer was loose and we all joked about it…but we always did our assigned "12:30" and nothing ever happened.*

Without exception, everyone felt that they learned responsibility at an early age, while protecting younger classmates. It was one small part of growing up—something that helped us transition from children to civic-minded adult members of the community.

Chapter 13

HOUSE RULES

Growing up, we were in and out of one another's homes, interacting with friends and their family members. Although we shared certain values and outlooks, there were areas in which people differed. Here are some of the acknowledged "house rules."

AUTOMOBILES. Ford versus Chevrolet was a classic one, with loyalties that could last for generations. My Dad avoided this discussion by remaining loyal to Chrysler's products—Plymouth and Dodge—from the mid-1930s onward, before finally becoming a Chevy guy in 1964. The other big automotive debate involved transmissions, but once most Moms began driving, a family's new car was invariably an automatic.

BANKING. Every Italian family had a relative "who worked with A.P. [Giannini]," Bank of America's founder, and many of these families did business there. Likewise, all newly arrived Irish immigrants would quickly be steered to Hibernia Bank. Such ethnic loyalties existed for most of the twentieth century, until Hibernia (founded in 1859) was acquired by Security Pacific Bank in 1988, which was acquired by Bank of America in 1992, which was then acquired in 1998 by an obscure North Carolina institution that adopted the BofA name. Do I even have to mention that it has been more than forty years since the robbery at Hibernia's 22nd and Noriega "Patty Hearst" branch?

BATHING. The nighttime bath before bedtime was standard for kids, but once we were older, it was a family battle to get into the bathroom to take a

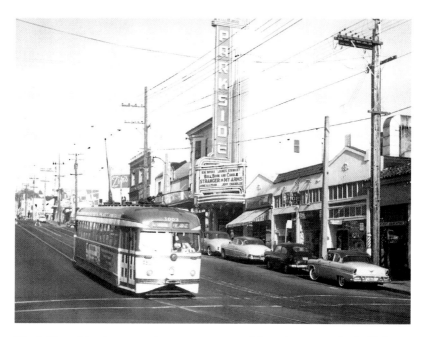

The L-Taraval has been carrying passengers to and from downtown via the Twin Peaks Tunnel since 1919. The K-Ingleside (1918) and M-Oceanview (1925) use the same tunnel, while the N-Judah (1928) uses the Sunset (Duboce) Tunnel. *Jack Tillmany Collection.*

Fun-Tier Town was a small western-themed amusement park that was developed adjacent to Playland in 1960. *Author's collection.*

morning shower. How did so many families survive with just one bathroom in those days?

BIRTHDAY PARTIES. These were frequently held in those downstairs knotty pine rooms. In 1960, however, a new section of Playland-at-the-Beach opened—Fun-Tier Town. In an Old West atmosphere, complete with carnival rides, youngsters could celebrate with their friends and then sit down to birthday cake, at a cost of just two dollars per person, with no cleanup necessary for mom.

CAN OPENERS. In the 1950s, every kitchen had a wall-mounted, hand-crank can opener near the sink. By the 1960s, along came the automatic electric can opener—and what mom wasn't thrilled to get one of those for Mother's Day, huh? Today, everyone has an electric model, and most young people wouldn't even know how to operate that old wall-mounted version.

CARPETS. With hardwood and parquet floors installed at the time of construction, most neighborhood homes had room-size rugs and long hall runners to protect the surfaces and to warm things up a bit. Following the lead of suburban homes (with only plywood floors), wall-to-wall carpeting became the new "must have" by the 1960s. Today's home buyers are often thrilled to pull up old avocado shag to find pristine hardwood floors beneath to accent their room-size rugs.

CEMETERIES. Among Italian families, one debate has raged on for generations: "consecrated" versus "unconsecrated" ground as one's final resting place. Both the Italian Cemetery and Holy Cross continue to fill up steadily, so there appears to be no clear-cut winner here.

CHRISTMAS. Families with small children needed all the prep time possible to be ready for Christmas, so when there were little ones, opening presents took place on Christmas morning. As we became teens, attending late-night adventures with friends and classmates, early morning festivities were not as much fun for anyone, hence the shift to gift-opening on Christmas Eve.

COLLEGES. My father and his brother went to USF, but their many cousins, male and female, all made the trek to University of California–Berkeley. Dad's argument for USF was that he could get to the classroom door with a single streetcar ride, while his cousins had to take a streetcar, a ferryboat and then another streetcar to do the same thing.

COUNTERTOPS. By the mid-1960s, many homes in the Western Neighborhoods were getting older, and owners were updating their kitchens. One of the big discussions was countertop material—there were generally only two choices, tile and Formica, since the time had not yet come for granite, marble, Corian, butcher block, stainless steel, polished concrete and

Ignored by most college recruiters, Bill Russell was offered a basketball scholarship by the University of San Francisco before going on to pro fame. *Author's collection.*

so on. The firm of Mayta-Jensen was highly favored, and its name in real estate ads ensured a good turnout at Sunday open houses.

DINING ROOMS. For most of us, these were used only for company, or typing up high school and college term papers. No one I grew up with ate dinner there every night like TV's Cleaver family.

DISHWASHING. Once dishwashers became standard, the old argument of "running water versus dishpan" was replaced by "rinse versus don't rinse" before placing items into the dishwasher. After more than fifty years and numerous improvements, that last controversy rages on. There is also a corollary argument of whether to put "good dishes/glasses" into the dishwasher, but I won't even go there.

A visit to the Easter Bunny at the Emporium-Stonestown was a standard springtime activity, 1955. *Author's collection.*

EASTER. In a seeming contradiction to the Christmas Day versus Christmas Eve debate, many families with small children celebrated Easter with dinner—ham or lamb being a separate Irish/Italian ethnic distinction; I suppose this arrangement gives parents more time to get kids ready for church in the morning. As my friends and I became teens, though, it seemed that all of our families embraced the Easter brunch after church, thus leaving everyone free to pursue their own afternoon and evening activities.

FIREPLACES. In our neighborhood, there were clear lines drawn—some families used their fireplaces regularly, and others were proud to have one with an unblemished brick interior. My parents were among the non-users,

so naturally, when I bought my first house, one of the first things I did was to invite them over for dinner and build a fire. That never swayed them from their position, although they did seem to linger over coffee and dessert, enjoying the crackling flames.

Gifts. To save or discard gift wrapping paper? There seem to be equal numbers of adherents on both sides of this question, with pained expressions on the faces of half the people in the room every time they watch the other half open a gift. Why is it that people of different beliefs on this issue invariably end up in the same family?

Hanukkah. Celebrate the first night or all eight? The answer was usually directly proportional to the number of young children in the household.

Illness. Every medicine chest contained a thermometer, but most moms judged temperature by pressing their lips against a forehead, with only one of two conclusions: "It's nothing" or else "You're burning up." In the case of upset stomachs, the patient was limited to tea and toast for a day or two, and if that stayed down, a soft-boiled egg might be added. Measles always required a darkened room and the absence of television.

Laundry. As automatic dryers became popular, clotheslines began to disappear, forever changing the landscape of backyards. Yet there is still something special about falling asleep in a bed made up with freshly laundered cotton sheets that were hung out to dry on a clothesline.

Magazines. Most families subscribed to something—*Life*, *Look*, the *Saturday Evening Post* or *Reader's Digest*.

Manners. At home, it was generally easier to get through a meal when parents gave in to a few childhood preferences—like my lifelong aversion to green peas. If, however, we were invited to dinner at a friend's house, or if we had company, heightened table manners applied—summed up nicely as: "Just hold your breath and swallow whatever is served."

Medicine. There must have been a "Mom Training Course" that decreed that aspirin, Bactine, Band-Aids and Phillips Milk of Magnesia—plus generous doses of dry toast, weak tea and chicken soup—were proven cures for at least 90 percent of childhood ailments.

Monopoly. Every family tweaked Monopoly's official rules slightly—mostly by placing a certain amount of money (a $500 bill from the bank at the outset of the game or sometimes all the fines required by Chance and Community Chest cards) into the middle of the board, to be collected when a player landed on "Free Parking." Extra turn when rolling doubles? Does the bank make extra money, houses or hotels when it runs out? Check the "house rules" in advance.

Movies. The Catholic Legion of Decency published film ratings that were monitored by some families, but not all, and this might limit the movies we could see with our friends.

Newspapers. When San Francisco still had two morning newspapers, Democratic households read the *Examiner* and Republican households read the *Chronicle*. One incident caused readership defections, though, and that was when columnist Herb Caen (1916–1997) switched papers in a contract dispute. After twelve years of writing for the *Chron*, Caen moved to the *Ex* in 1950, and some fifty thousand loyal readers followed. When he returned to the *Chron* in 1958 for his remaining thirty-nine years, that same crowd of fifty thousand followed him right back. Very few households bought the Sunday paper late on Saturday, and that just seemed odd.

News Programs. Walter Cronkite ("And that's the way it is…") took over the New York–based *CBS Evening News* in 1962 and presided there until 1981, rightfully earning his title as "the most trusted man in America." Yet there were some households that favored the *Huntley-Brinkley Report* ("Good night, Chet…Good night, David"), which ran from 1956 to 1970, featuring anchors from both New York City (Huntley) and from Washington, D.C. (Brinkley). I'm still trying to remember what made people favor one program over the other, but I'm drawing a blank.

Pets. For our neighbors who had pets, there seemed to be more dogs than cats. Given the big backyards, and the fact that most moms were home during the day, dogs could easily go in and out at will. Today, with many homes sitting empty while everyone is at school or work, the self-sustaining cat population is on the way to outpacing the dog group. And it was a rare parent who could say no to a child's desire for a pet. Even the most adamant like mine allowed those goldfish won at the local parish festival.

Politics. Our neighborhood was pretty evenly divided between blue and red households; some were divided within themselves between husband and wife—*don't even think about talking politics there!*

Radio. Many homes still had big console radios in the living rooms, whether or not they still worked—the tubes were getting to be hard to come by once TV was on the scene. Most moms worked in the kitchen with a radio playing in the background, and even in the 1960s, many kids were overjoyed to get their first transistor radio that could be placed into a pocket with a wired earpiece for private listening.

School Plays. It was a given that parents attended school plays, assemblies and recitals involving their own children, but we also did so for the children of our neighbors, and they returned the favor.

ST. CECILIA SCHOOL
presents

The Gay 90's Review

May 16-17, 1960
7:45 p.m.

A 1960 school pageant program. Generations of proud family members have attended musical, dance and stage performances by local students for decades. *Courtesy of Jo Anne Quinn.*

SHAVING. When it came to shaving, most dads preferred a blade, single or double-edge. The few who once used a straight razor were universal in the comment, "That was thrown away the day we brought the first baby home." Some guys, like my uncle, preferred electric, and that's what I started with, but sometime in college, it just seemed easier, faster and more comfortable to shave with a blade, which I still do.

STOVES. Most houses had gas stoves, but by the 1960s, electric ranges had begun offering self-cleaning ovens, and there was a transition to AEK (all-electric kitchen). By the 1990s, however, many buyers were opting for restaurant-style gas models.

TAXES. Moms and dads sitting at the kitchen table after dinner every night with shoeboxes full of receipts meant that it was April. No one we knew ever went to a "tax preparer," but today, no one I know feels capable of performing this task alone.

TOYS. GETs at 34th Avenue and Sloat Boulevard had an impressive toy collection at discount prices. Toy Village on West Portal and King Norman's on Clement also carried a good variety and could be counted on when the discounters were sold out of an item. The granddaddy of them all, however, was the Toy Department at the downtown Emporium, Fourth Floor at the back, which had absolutely everything.

Replacing the old "charge-a-plate" with a modern credit card in the 1960s, Emporium (1896–1995) eagerly sought a new generation of customers for its goods—"everything from a needle to an anchor." *Author's collection.*

TELEVISION. Most homes had exactly one, so when *Perry Mason* and *Bonanza* were broadcast opposite each other on Saturday nights, from 1959 to 1961, there were family disagreements throughout the neighborhood, resulting in many people joining like-minded neighbors who watched the same program. Come to think of it, this was the time that many families started acquiring a second TV for the master bedroom.

UNDERTAKERS. It used to be Carew and English, but now Arthur J. Sullivan (owned today by two brothers—one living in the Sunset and one near West Portal) seems a popular choice. It merged with Duggan's in nearby Westlake in 2007, and it was recently announced that the third-generation Sullivans have signed a contract to develop their Market Street property into a large, multi-unit housing complex within the next few years.

VACATIONS. Russian River, Lake County or Marin Town & Country Club? Every family had its favorite spot, generally returning year after year.

WINDOW COVERINGS. Mr. Doelger and other builders must have had stock in venetian blind manufacturers, since virtually every home had these installed in the front windows. By the 1960s, many people began installing draw drapes, even though this had the unanticipated effect of letting everyone know just who was watching the neighborhood. Mom and her longtime friend Dorothy across the street went with draw drapes eventually, but only *in addition* to venetian blinds. The two of them would say, in unison, "I don't want the neighbors to know that I'm watching…"

Chapter 14
OUT AND ABOUT

Was everyone out and about more in the old days? It certainly seems that we were. Looking back, I can remember family and friends getting out of the house regularly for things beyond just work and grocery shopping. Visiting family and friends, attending meetings (Eastern Star, Knights of Columbus, Parent-Teacher Association, Mother's Club, Father's Club, Shriner's) or going out for a bowling game, watching Little League, going to children's school performances or simply taking a night at the movies were all regular events in the lives of most people. Libraries used to be open sixty-eight hours per week as late as the early 1970s, and most folks did at least some of their errands on foot, as opposed to driving everywhere, as is the case today. As the city has changed, though, so have our leisure-time activities, and a lot of folks seem to be remaining indoors more and more, huddled over their electronic gadgets rather than mixing and mingling with one another.

There was a time when most of us had dozens of aunts, uncles, cousins and more distant relations living just a short walk or ride away, and visiting was a popular pastime. Families today might not have that luxury, and visits often have to be planned and coordinated well in advance on both sides. Growing up, our family often went over to someone's house after dinner "for dessert" and to look at color slides of that person's newest grandchild or recent trip to Guerneville. Somehow, sending the same photos electronically is not much of a social experience.

Most houses of worship were packed to the rafters for services until the late 1960s. Then, slowly, one by one, the number of services was reduced

A cheerful crowd of San Franciscans seeing someone off at the train station, 1949. *Westerhouse Family Collection.*

because of dwindling attendance. Some smaller stand-alone churches closed, often for financial reasons—it takes money to light and heat a cavernous older building. Some Jewish congregations merged, based on the geographic moves of their membership. And in the 1990s, the Catholic Church eliminated geographic "parish boundaries," allowing people to choose their own place of worship, eventually leading to circumstances in which some once-popular churches were closed and the properties sold off.

Dad always managed to get tickets for Giants-Dodgers double-header games in the summer, and they did not cost him a fortune—in fact, we often took school friends along with us, and including lunch and parking, I don't think we ever spent much more than twenty dollars for a full day's entertainment. Today, the cost would be prohibitive for many average-income families—likewise for 49ers tickets.

Thousands of alums were regulars at the annual Lowell-Poly football game (back when Kezar held fifty thousand people), but the loss of Poly in 1972 eliminated a popular seasonal event for them. And although

The Scottish Rite Auditorium at 19th and Sloat replaced the blue glass–walled Hallowell's Nursery more than fifty years ago. *Woody LaBounty photo.*

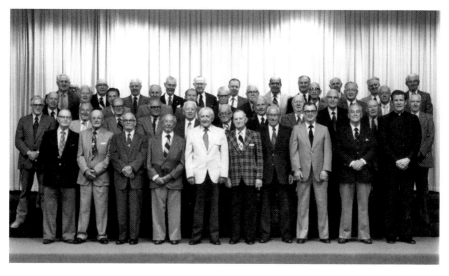

At a time when many churches were being locked during the day because of crime, the Knights of St. Cecilia's group was formed in 1980 to provide daytime security for the church and its visitors. *Rita Ann Smith photo.*

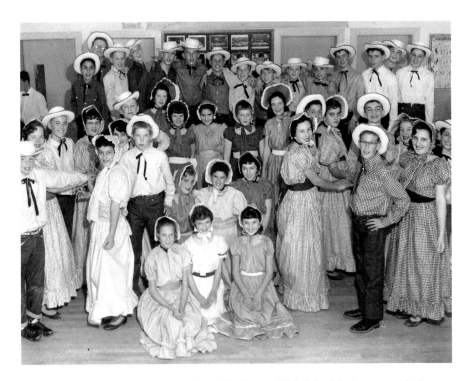

The 1965 cast of *Young Hearts in Showtime* at Washington High School had costumes similar to these in an *Oklahoma!* skit during the 1957 production, *Song of Siena*, at Our Lady of Siena School in Martinez, CA. *Mary-Ann Orr photo.*

the S.I.–Sacred Heart rivalry still draws fans for the three major prep sports—football, basketball and baseball—many of today's S.I. families live in San Mateo County and elsewhere, thus limiting their likelihood of attending night games.

In addition to social and service groups for adults, there were also those that catered to the younger generation. Every Catholic parish had its own Teen Club—a place to meet and mingle once a month and at periodic dances. St. Francis Episcopal Church on Ocean Avenue organized a group known as St. Francis Assemblies, which also promoted well-chaperoned dances for teens in the 1950s and 1960s, and the Jewish Community Center offered dozens of programs. These definitely seem to be drawing fewer attendees, perhaps because some people prefer not to be out at night or because many participants no longer live in San Francisco. Choruses, choirs, sodalities, recitals and amateur stage productions used to have frequent nighttime rehearsals and performances in the past. Even school crossing guards (then known as traffic boys, even though there was gender equality in the ranks at

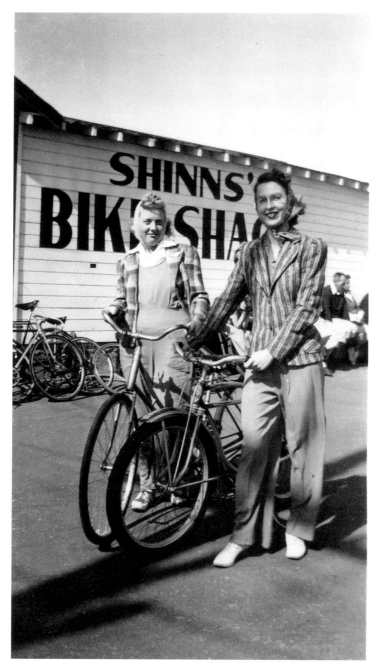

Shinn's Bike Shack. Bicycle riding near Golden Gate Park and along Ocean Beach, shown here in 1945, remains a popular activity. *Judy Hitzeman photo.*

many schools by the 1960s) had regular meetings and an annual afternoon assembly at Kezar Stadium or the Polo Field just before the end of each school year.

Spending the day at Fleishhacker Pool, whether swimming or just people-watching, was an activity favored by young and old alike, and many people visited Sutro's or Playland or the zoo for no particular reason other than getting out and socializing a bit. When I was small, my parents' idea of a Sunday afternoon was a drive to the airport to watch planes taking off and landing and talking about faraway places that we might visit someday.

Even my widowed grandmother understood this concept after Grandpa died in 1957. Suddenly faced with a quiet house, she did not resort to the electronic distractions of her time—radio, telephone and television—for her daily activity; rather, she forced herself to get out and socialize with others. She signed up for senior sewing classes offered through City College and improved her already good skills. Other days, she was on the bus, visiting the adult children of her cousins, meeting old friends for coffee at Foster's in Stonestown, going along with one of her sisters or sisters-in-law for an afternoon of shopping the Emporium's great old bargain basement on Market Street or taking a Greyhound bus to Tahoe for a short visit with a favorite nephew and his family.

Today, I completely understand when friends announce that they are taking a social media break for a while. Avoiding electronic distractions and spending more time actually mingling with others is just as important for us today as it was for Grandma more than half a century ago.

Chapter 15

IN THE GOOD OL' SUMMERTIME

To many families, summer always meant spending time outdoors. For some, that meant a trip to Fleishhacker Pool, but for many, summer was not complete without a visit to the Russian River (aka the Irish Riviera). My grandparents, along with a group of their friends, were regulars at Johnson's Beach in Guerneville in the days before their 1910 marriage. Later, in the post–World War I era, they repeated those visits with their two boys. Old family pictures show my father and his brother with their straw-hatted parents floating down the river in a canoe named the *Dew Drop*. Dad loved to tell the story of taking the ferry to Sausalito, then the train—either broad gauge or narrow gauge, depending on the destination—to Rio Nido, Monte Rio or Guerneville throughout the 1920s.

Later, during his time at University of San Francisco in the mid-1930s, Dad and his brother, along with some of their school pals, used to make the drive to Yosemite in the summer and to Palm Springs (then a very remote and sparsely populated desert outpost) during winter break. Finally, in the last few years before World War II, my parents met each other for the first time at a dance at Seigler Hot Springs in Lake County, and they spent time there with friends each summer through 1941 and then again after their 1947 marriage.

Probably because of such patterns, my parents' attitude toward all of these highly popular places in the years after I came along was "been there/done that." Hence, almost of my visits to those vacation spots came when I was with my friends and their families or else as an adult, since

Fleishhacker Pool (1925–71), circa 1960, filled with warmed ocean water, was so large that lifeguards patrolled in rowboats. Maintenance became an issue, and the pool was demolished for a zoo parking lot. *Lorri Ungaretti photo.*

Mom and Dad invariably chose Marin Town & Country Club for almost all of our 1950s and 1960s summer vacations—except for a few times, when Disneyland was substituted.

Our annual pilgrimage always began with Dad driving us up to Fairfax on the Lincoln's Birthday holiday in February for the sole purpose of selecting a cabin for our three-week stay in August. Mom was the real boss in this matter, and her choice depended heavily on the looks of the kitchen in the available units. Most of the cabins were basic one-bedroom models, painted seasick green, both inside and outside, with white trim. Each one featured pull-out couches or hide-a-beds in the living room for the kids, so in most respects, it didn't matter very much which unit was selected, since they were pretty interchangeable. But oh, those kitchens…

Mom made it clear that she was not about to perform her culinary magic on any stove that was less than a full thirty inches wide, as she had to do during one summer in the late 1950s when she was confronted with a model only twenty inches in width, containing an oven that would handle nothing larger than two Swanson TV dinners at one time. She also insisted that the refrigerator had to be big enough to hold a week's supply of cottage cheese, watermelon, lettuce and popsicles—her summertime staples—and not an "apartment model" that would result in the need to go out grocery

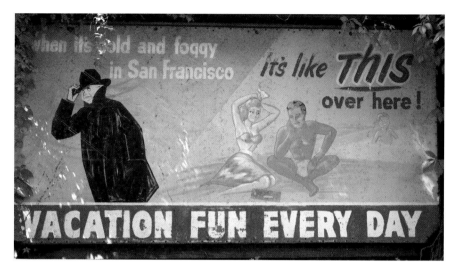

The classic "When It's Cold and Foggy" billboard that lured thousands of San Franciscans twenty miles north to Marin Town and Country Club in Fairfax for a bit of sunshine every April to October from 1944 to 1972. *John A. Martini photo.*

shopping every single day. Once this matter was settled and a cabin selected, our vacation plans were firmly in place; we anxiously awaited the first week of August.

Departure morning was always a Sunday, marked by going to church early and then having breakfast at the Tennessee Grill on Taraval near 22nd Avenue. Dad had the car packed to bursting with luggage, kitchen supplies (Mom thought that the dishes, utensils, pots and pans provided in the cabins were "unsanitary"), plus endless boxes containing bathroom essentials—did they think that there were no drugstores in Marin County selling Kleenex or Sea and Ski suntan lotion or Band-Aids? Leaving the fog behind, we caught the first glimpse of sun on the north side of the Waldo Tunnel, and vacation was underway.

The Marin Town & Country Club complex was spread across twenty-six wooded and lawn-covered acres on the south side of San Anselmo Creek in the town of Fairfax. The site, once operated as a summer resort for employees of the Emporium, San Francisco's classic old department store, became an immensely popular public attraction after it was acquired by Max Friedman near the end of World War II. A series of strategically placed billboards throughout San Francisco alerted residents of the foggy city to the sunshine and recreational possibilities that lay just thirty minutes north.

With seven swimming pools (some appropriately named "Diaper Bay" and "Small Fry Tiger Pit" to denote the age/skill level) spread across a twenty-acre fenced area, access was controlled by tickets sold at the entrance. Exiting and returning to the paid area was accomplished with a daily-changing rubber stamp applied to the left hand of paid visitors—"MARIN," "SUNSHINE," "SWIMMING" and "PICNIC" are among the several evocative messages that still come to mind.

Our days were spent with swimming, sun tanning and endless games of shuffleboard, horseshoes or ping-pong with other kids from San Francisco, whose families occupied cabins adjacent to ours for several summers. Basketball, baseball and volleyball were also available, and for a short time, there were trampolines that rented for fifteen minutes at the rate of twenty-five cents. (Needless to say, this last amenity disappeared quickly once the resort's insurance agent got wind of the activity.)

Summertime meals were always easy for the tight-knit community of summer families (almost all from Western San Francisco) occupying the cabins. Most of the moms decreed that self-service cereal and milk were the only weekday breakfast offerings, while picnics were the order of the day for lunch. Throughout the day and the early evening, there was also a centrally located snack bar that dispensed snacks and rivers of Coca-Cola (plus Burgermeister beer for adults and the phony card–carrying near-adults) in yellow and green waxed paper cups, while the blaring jukebox pounded out such hits as "Walk Right in, Sit Right Down" by the then-popular group the Rooftop Singers.

Each night, the air was heavy with the rich smell of charcoal as the vacationers in all the cabins surrounding the perimeter of the property prepared dinner. Throughout those days, I worked on developing my barbecue skills on a grill with an electric rotisserie attachment. Like most pyromaniac-inclined preteens, I discovered that old waxed cardboard milk cartons, stuffed with charcoal and paper towels and then subsequently doused with generous amounts of lighter fluid, made for an exceptionally fine fire.

Since television reception at the time was virtually zilch in that location, the management put on a variety of evening entertainment. This ranged from old 1950s films (*The Solid Gold Cadillac* with Judy Holliday and *The Bell Boy* with Jerry Lewis are two that come to mind, even today) to low-stakes bingo, swimming and outdoor ice cream sundaes.

The old Redwood Bowl, a covered creekside dance pavilion on the property (eventually washed away in a series of winter storms in 1981–82),

had been popular both before and after World War II, but it was largely unused by the late 1950s. Even so, it brought back many sentimental thoughts to those in the parental generation. More than once, as a family was walking in or out of the complex, someone would turn and point across to the site, and when I was about nine years old, I actually saw my own parents glance over in that direction and then join hands and dance a few steps on our way to the parking lot. My dropped jaw was silent testimony to my youthful amazement that the old dinosaurs, then past forty years old, would have even known about something as racy and risqué as dancing!

At some point during our stay, Grandma would come up to visit, often with an aunt or uncle and some of our cousins. She would always bring along her incomparable chocolate chip cookies, raisin cupcakes and a box of See's Summer Mix candy from one of her sisters, plus several fresh rolls of black-and-white film for picture taking. Tucked into her big straw tote bag would also be all the newspaper obituary sections from the weeks that we had been gone, so that the adults could discuss and stay current on what was going on back home. Like many grandmothers of the era, her few fashion concessions to the warm weather involved wearing a flowered muumuu and a large straw sunhat, along with ankle stockings and sturdy-heeled white lace-up shoes.

By the 1960s, the management had installed several large Jetson-like iron structures, shaped like gigantic sun umbrellas, throughout the huge expanse of lawn in order to provide a welcome bit of shade from the blistering summer sun. There was also a stage with speakers, set up on a high platform, designed to blast the Top 40 hits of the day to those who had not thought to bring along their own transistor radios on Saturdays and Sundays.

By the end of our second week, with the temperatures soaring into the nineties, most of the kids in the cabins surrounding ours had all grown restless with the sun and swim routine. One of the moms, generally the owner of a station wagon, was invariably persuaded by several of the other parents to take a group of kids to an air-conditioned theatre (either the nearby Fairfax or else the Tamalpais in San Anselmo) for an afternoon double-feature, usually involving John Wayne, the Three Stooges or Donald Duck, depending on the predominant age group of the kids in tow. This was, indeed, a pleasant break for one and all, except possibly the adult driver of the vehicle.

Slowly but surely, the end of vacation would be in sight. The blazing heat of early August became a bit more subdued, with the evenings growing

noticeably cooler and dusk falling just a bit earlier each night. This would be our sign that summer was gradually coming to an end, although we enjoyed ourselves immensely, right up to that last dip in the pool on a warm Saturday evening the night before we were due to head home. Regardless of where we went, though, we always returned to the fog of the Western Neighborhoods by Labor Day, tired and sunburned but recharged and ready for another year of school and work.

Chapter 16

FAITH, HOPE AND CHARITY

S an Francisco's Western Neighborhoods have many houses of worship that were established in the area's early days, along with others that relocated at various times from the Western Addition neighborhoods, following the progression of members.

The architecture of these buildings has created a kaleidoscope of color and style across the skyline of the neighborhoods—from the massive red-tiled Byzantine dome of Temple Emanu-El at Arguello Boulevard and Lake Street to the golden onion domes of Holy Virgin Russian Orthodox Cathedral at 26th Avenue and Geary to what the late Herb Caen often called the "timeless twin towers" of St. Ignatius Church at Fulton and Parker. The Voice of Pentecost Church, at the site of the old El Rey Theater for decades, is a strong neighborhood presence near Ingleside Terraces, just as the modernistic oval Holy Name Church in the Outer Sunset and Spanish Colonial St. Cecilia in the Parkside are to those areas. St. Francis Episcopal Church on Ocean Avenue recently celebrated the seventy-fifth anniversary of its facilities, and several smaller congregations have built large new churches over the last twenty years, as corner lots throughout the city have become available for development due to the closure and demolition of so many gas stations.

In addition to worship services, many of these groups also support related schools, hospitals and care facilities for both youth and the elderly throughout the Western Neighborhoods, and over time, many have adapted their missions. A number of orphanages used to dot the landscape, but for decades

Originally erected by the city in 1934, the Mount Davidson Cross is now owned and maintained by a private group, the Council of Armenian-American Organizations of Northern California. *Tim Adams photo.*

now, the preferred method of support has been placement of the child in a foster home. Homewood Terrace Orphanage on Ocean Avenue, run by the Jewish Family and Children's Services, was redeveloped into housing and retail in the 1980s, and Edgewood, the old Protestant Orphanage on Vicente Street near 30th Avenue, has refocused its mission on providing care and support to at-risk youngsters who are not necessarily orphans.

Care for its elderly and infirm members has long been the goal of the Christian Science Benevolent Association at its Ardenwood facility at 15th Avenue and Wawona. Likewise, St. Anne's Home, run by the Little Sisters of the Poor, has been a fixture at 4th Avenue and Lake Street since 1900.

When its imposing red brick building was declared unsafe in the 1970s, the group launched a massive fundraising drive and, in 1977, opened a state-of-the-art facility with more open space facing Lake Street. In a small nod to history, the architect of the new building preserved the rooftop cupola from the old structure and converted it into a gazebo on the front lawn of the new complex.

As redevelopment played out in the Western Addition and South-of-Market, many houses of worship followed their congregations to the Western Neighborhoods, among them Temple Beth Israel, located on Geary near Fillmore, which moved to Brotherhood Way when it merged with Temple Judea in 1969, and Pine United Methodist Church, San Francisco's oldest Methodist congregation, founded in 1886, opened its new church on 33rd Avenue and Clement in 1965. Holy Trinity, the largest Greek Orthodox Church west of the Mississippi, moved from a downtown location on 7th Street and opened its new quarters on Brotherhood Way in January 1964.

Declining attendance caused the Roman Catholic Archdiocese to reevaluate several parishes, including St. Edward's on California Street, which was closed; its building was demolished, and the land was sold for condos in the 1990s. Even so, many smaller denomination churches have seen increased attendance, with several new houses of worship springing up throughout the Western Neighborhoods in recent decades.

While there is tremendous diversity among these institutions, strong ties bind them together in times of trouble—such as when the freeway threatened the neighborhood in 1955 or when many groups opened the use of their facilities to one another because of damage from the 1989 Loma Prieta earthquake. Changing memberships will likely continue to bring about major collaborative efforts among these many groups.

Chapter 17

GIVING THANKS

As the leaves begin to turn, a nip in the air is felt and football games begin, we all begin to have thoughts of holiday gatherings and get-togethers, the first of which is Thanksgiving itself. Many families have traditions that are set in stone—the crystal dish of Grandma's that has held nothing else besides Ocean Spray jellied cranberry sauce in its entire life, the remaining wine glasses from Mom and Dad's 1947 wedding used for a toast or that aluminum Jell-O mold that is precisely the right size for the traditional mandarin orange salad. Times, however, change. People come, and sadly, others go. Yet the traditions go on, as we wish them to, each and every November.

I know that whenever I relate my own family's stories of Thanksgivings past, I get a series of all-knowing nods from friends and strangers alike, suggesting that they, too, have been down the same well-trod holiday paths as my own relatives. Join us now for a stroll down a Thanksgiving memory lane that will be familiar to many of us.

When I was growing up in the 1950s, Mom decided early on that it was not an easy thing to separate a child from his Christmas presents, so why bother trying? She and my father wisely judged that it was best to spend Thanksgiving with relatives and then to stay home in December, playing host to family and friends. This simple idea set the pattern for our Thanksgiving and Christmas celebrations for decades.

With that in mind, Thanksgiving always belonged to the grandmothers, and we alternated between the two of them year after year. Dad's widowed

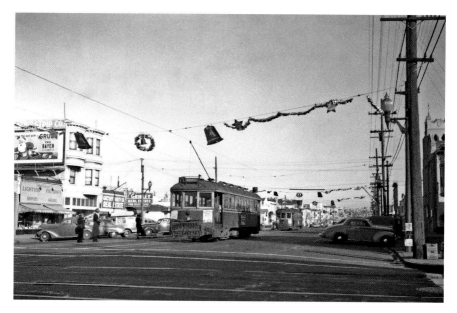

Streetcars on Geary near 8th Avenue, with holiday decorations installed the week of Thanksgiving 1948. *Jack Tillmany Collection.*

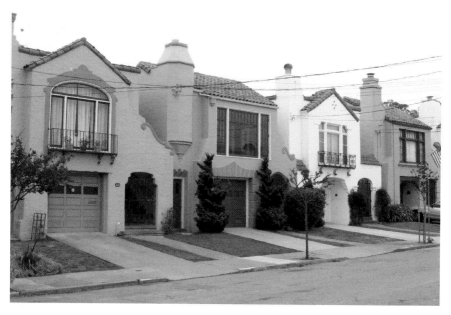

Homes on 18th Avenue near Vicente, nearly eighty years old, are well maintained and have seen generations of the same families gathering together since 1936. *Woody LaBounty photo.*

mother on 21st Avenue and Rivera had some of her own rituals, one of which I've resurrected. Starting in late October, Grandma would save all the crusts and bits of leftovers from all her loaves of bread, English muffins, biscuits, rolls, crackers, French bread and so on as the basis for her turkey dressing. One of my first kitchen projects was to help her break up the pieces and then feed them through her mother's old metal meat grinder that she bolted to her kitchen counter. Type of bread didn't matter—croissants, raisin bread, stale biscuits and corn muffins all went into the grinder, and when mixed with chopped celery, onion, parsley and golden raisins, the whole thing combined to make far more than the sum of its parts—the most delicious turkey dressing that I can ever remember.

That grandmother forced everyone into a pre-meal ritual that would have been the envy of any religious group that still promotes fasting. Not only was there nothing to eat before dinner, but guests were also encouraged to skip lunch on Thanksgiving Day. My other grandmother, Mom's mother, always insisted that there be some appetizers before dinner, but nothing too heavy ("you don't want to spoil your appetite"). She set out tray after tray of stuffed celery—medium sticks filled with a variety of soft cheeses and topped with paprika, along with a few assorted olives and nuts; grown-ups were entitled to one cocktail, and kids could have one glass of root beer, but that was her limit for pre-meal snacking.

Mom's mother had seven grandchildren, and so all of us cousins were relegated to the "children's table," which we didn't like at the time but which brought about the formation of certain bonds of closeness and affection between many of us that still exist today. That children's table largely disappeared once there were no preschoolers left, and we all joined in at the grown-up table after that and finally got to know all those great-aunts and great-uncles, along with Grandma's cousins and their families. By the time I was ten, I could define the phrase "second cousin once removed," and knew that I had several, one of whom, Carmel, the mother of five, I liked very much.

The practice of having children cut out autumn leaf– or turkey-shaped place cards from sheets of yellow, orange and brown construction paper, and then printing each guest's name on them, was always a good way to keep idle hands busy during a hectic afternoon. It worked well with me; I used it with my godchildren throughout the 1980s. With any luck, I'll be trying it again soon with a whole new generation. Understanding that someone you know as "Aunt Bun" also goes by the real name of "Veronica McEnnerney" is very enlightening for children, as well as a good spelling exercise for them.

By the 1960s, with one grandmother gone, the other picked up full-time Thanksgiving duty. She always insisted that food had to have the right color to match a particular holiday. With this edict in mind, Mom relied on a neighbor's suggestion, circa 1967 or so, that remains with us to this day: mandarin orange salad, a Jell-O-based salad with tiny orange segments and orange sherbet. It's light and refreshing and has graced every Thanksgiving table in our family for well over forty years now, and I'm constantly being asked for the recipe.

The turkey, of course, was center stage, and Grandma used to pick up several extra drumsticks at the butcher, just so that there would be no squabbling among her adult children and their spouses about who was getting their favorite part. Some years, the center of her dining room table looked like an advertisement for the chorus line of the Radio City Music Hall Rockettes. This is one tradition that I've allowed to pass into quiet oblivion.

When I was in college, my last grandmother died, and Mom's sister took over Thanksgiving. For more than twenty years, my Aunt Margaret's apartment at Stonestown was Thanksgiving Central for our family. The aromas lingering in the lobby and the elevators foretold the treats to come from every one of the ninety kitchens in the building that day, and our mealtime photos show that glorious sunset view from those towers out to Lake Merced and beyond, with a red-orange sky as the backdrop to our celebrations. Virtually every photo from the time shows Mom and her sister, backs to the camera, attending to last-minute prep work in the kitchen, both of them outfitted with Grandma's old aprons. Mom was destined to be the last of her siblings, and she took over the role of Thanksgiving hostess after her sister died in 1992, holding a firm grasp on it for the next ten years, until the mantle was passed to me. I've preserved many elements of the past and tweaked a few others to my own liking.

Vegetables are seldom warmly embraced by most meat-and-potatoes Irish families, and ours was no exception. Grandma's standard choice was a couple of boxes of frozen peas and carrots, boiled to death, but thankfully that has faded from the scene. Nutritionally, I acknowledge that there must be at least one green vegetable. Mom used to make German green beans— fresh green beans, cooked with onion and then marinated in oil, vinegar and pepper and reheated just before serving. One year, my friend Linda, also ethnically Irish and German, just like Mom, persuaded her to leave the big chunks of onion mixed in with the beans when serving them, thus bringing the whole dish up to a new level.

Herman's, a classic, aromatic, old-time deli located for decades on Geary near 8th Avenue, could provide food for everything from a picnic to Thanksgiving dinner. *Author's collection.*

Opened on the site of cabbage fields in 1952, Stonestown marked the beginning of a new era in shopping and modern apartment living. The mall was rebuilt in 1986, and the apartments were sold to SFSU in 2005 for student housing and are now known as University Park–North. *Courtesy of Prelinger Library.*

Now, I happen to like sweet potatoes, but what some American cooks did to them beginning in the 1960s seems almost like a *Mad Magazine* satire on food preparation. I've seen them covered in marshmallows, doused in Kahlua and buried under boxes of brown sugar with cubes of butter piled on the top. Most of these methods leave me cold (and perhaps nauseated). My favored method is simply baked and then puréed with butter, salt and pepper. One year, my friend Linda brought along a baking dish filled with hollowed-out orange shells filled with a rich mixture of sweet potato, butter,

ricotta cheese, sour cream and orange juice. Oh so good, even though you could hear heart ventricles slamming shut all around the dining room table with each bite consumed.

Yellow is another favorite color for Thanksgiving vegetables, and corn usually tops the list, whether served plain, creamed, baked, as corn fritters or otherwise. I've had some success with corn soufflé recipes, although I've migrated away from the one that requires eggs to be separated and beaten, combined gently and then stirred four to six times during its thirty minutes in the oven. The dish currently in favor among my family involves a combination of canned corn, milk, eggs, cheddar cheese, Corn Chex cereal and some seasonings. Mix it all together, plop it into the oven for forty-five minutes, more or less, and it comes out great. Bake it too long, and the top just gets extra crunchy—nothing like flexibility on Thanksgiving!

Over the years, I've attended a few cooking classes and made the acquaintance of a couple of cookbook authors, and I've tried introducing some of their favorite side dishes to holiday proceedings. One is pickled baby carrots, and another is cheddar scalloped baby onions. Everyone consistently remarks about how good they are, and everyone dutifully eats exactly one piece before passing the dish on to the next person. One friend, who specifically asked me to bring along the onion dish, remarked, "It just would not be Thanksgiving without those onions." I later learned that such a statement does not necessarily mean that the speaker actually *likes* the onions—it just means that she feels it would not be Thanksgiving without them. Given the slow rate of consumption, I began to estimate my preparation costs as one dollar per baby onion (lots of ingredients), but oh, the leftovers are good.

Then there's cranberry sauce. Everyone I've ever known has some sort of clear glass or crystal dish (usually having belonged originally to Grandma) that has held nothing else in its seventy-five-year lifespan but a can of Ocean Spray molded cranberry sauce each and every Thanksgiving. The first year that I worked for a popular San Francisco–based kitchenware company, I won several jars of "Holiday Cranberry Relish" in a contest at work. Proudly serving the gourmet treat, I had glares from around the table and was severely questioned as to "Where's the cranberry sauce?" My explanations were futile, with one guest hurriedly dashing off to the old faithful Eezy-Freezy Market on West Portal, where a veritable mountain of Ocean Spray cans had been stacked up at the checkout. People don't mind variety, but the host must never overlook the basics.

Finally, dessert would arrive and, with it, high expectations of tradition. Like millions of other households, there would always be both pumpkin and apple pie. My late Uncle Jack was the last person I ever remember who truly loved mincemeat pie—an acquired taste, to be sure. Mom would dutifully send me off to the old Ahren's Bakery on Van Ness Avenue on Thanksgiving morning, so that she could round out the dessert offerings with Unc's favorite, and although he left us in 1988, we still reminisce about his favorite dessert.

Beginning in the early 1990s, my St. Helena cousin Kathy began joining us with her family, and every year, as faithful as clockwork, she would arrive with not one but *two* homemade lemon meringue pies. This became a colossal new holiday sensation in our family—cool and refreshing (and also adhering to Grandma's insistence on colorful), while cleansing the palate after a heavy meal. Sadly, Kathy is gone now, but her daughter continues the tradition admirably.

Then, as now, we all converge on the living room afterward, polishing off the last of the wine, nibbling at bits of leftovers, watching replays of parades and football games, perhaps listening to Aunt Margaret's old Ray Coniff albums and thinking about how fortunate we all are, here with one another, knowing full well that each year brings about one change after another.

As we sit back and relax, we always reminisce a bit about those relatives and friends who are no longer with us, recalling treasured moments, their likes and dislikes and their famous or infamous sayings—setting the stage for the holidays to come.

Chapter 18
HOLIDAY CELEBRATIONS

G rowing up on the 2600 block of 18th Avenue in the 1950s guaranteed that we would be in full celebration mode by early December, since our neighborhood had a long history of outdoor Christmas lighting. From the time of its construction in the late 1930s, each home had a custom-built wood frame for displaying holiday lights around the front window. These frames, stored in the garage most of the year, were regularly passed on to new owners, and many neighbors added additional frames to surround the garage and front entrances with even more lights. Our block won several holiday lighting awards from the *San Francisco Examiner* and was widely known for its community spirit.

It surprises me today to see so many homes in the Western Neighborhoods without a single representation of the holiday season. Regardless of one's religious beliefs or non-beliefs, most people agree that the end of the calendar year is fast approaching and that a new year is close at hand. Those factors alone should certainly be cause for some form of outward celebration. Looking back, it is amazing how many decorating trends have come and gone.

Mom's parents always opted for a fresh green tree that would sit atop a table in the front window and be lit with medium-sized old-fashioned multicolor bulbs. I can still see my grandfather, pipe jutting out of his mouth, as he lovingly placed each strand of silver tinsel on the branches. That was in the day when tinsel was made of thin threads of real metal (usually silver-color lead) rather than plastic, and the same pieces were saved and reused year after year. Grandma always made popcorn and then had the

1950

Neighbors of Eighteenth Avenue
Between Vicente and Wawona Streets
DEAR FRIENDS:

Once again the Yuletide Season approaches and it is time for CHRISTMAS REJOICING!

As in the past we have decorated our homes with Outdoor Lights and displayed Christmas Trees in our windows—so, let us ALL get together and again follow our past custom.

To the new neighbors of 18th Avenue, we welcome you to our midst and trust that your residence on this street will be a happy and long one. May we ask that you all enter into the Christmas spirit that has been evidenced in past years and cooperate with us by decorating your home with outdoor Christmas lights.

No doubt there will be some of you who will need help in putting up your lights, so if you will call on the Committee Members listed below, they will arrange that some of the committee assist you in putting up the lights. They have several ladders, hammers, etc., on hand. If there is any neighbor who will be out of town or unable to put up his lights, kindly leave lights, extension cord and key to basement with his next-door neighbor and arrangements will be made to put up same.

Therefore, the following is suggested:

That we have our lights up by Saturday night, December 16, 6:00 P. M.

That the lights be on every evening between December 16 and January 2, during the hours of 6:00 P.M. to 9:30 P.M. Also, if for some reason you will not be at home on some particular evening, PLEASE ARRANGE with a neighbor to turn your lights on and off on that night.

To help defray expense of purchasing candy for the children a contribution of 50c would be greatly appreciated by the committee.

A RED FLARE will be the signal to turn on lights PROMPTLY at 6:00 P.M. We ask that the neighbors who so desire convene at 2695 - 18th Avenue where opening ceremonies and appointment of new Mayor will take place between 6:00 and 6:30 P.M. Marin Dell Santa Claus and his Reindeer Float will appear on street between 6:00 and 6:30 P.M.

Christmas Carols will be played on a public address system between the hours of 6:30 and 9:00 P.M. Come join with us and let the Yuletide spirit spread its wonderful feeling of happiness.

May all the neighbors on 18th Avenue enjoy A MERRY CHRISTMAS and A HAPPY NEW YEAR!

John Bernie, *Mayor*, SE 1-0067	Wm. Smith, MO 4-0417
"Buzz" Smith, LO 6-5308	Edwin King, SE 1-2153
Mark Stubler, MO 4-4862	H. Drexler, SE 1-5905
Howard Plank, MO 4-7370	V. Kelly, MO 4-7115
Phil Nyman, MO 4-7827	Frank Dunnigan, LO 6-4159
G. Wolfman, OV 1-4381	L. Deubler, OV 1-0928
George Cronin, MO 4-7560	Frank Norman, OV 1-3037

Neighbors living on the 2600 block of 18th Avenue supported a thirty-year-long outdoor holiday lighting tradition. *Christine Meagher Keller Collection.*

grandkids use a needle and thread to string it, interspersed with raw cranberries, because that's what she remembered from her girlhood Christmases in Colorado. The lights and glass ball ornaments—a couple of fresh boxes picked up each year from Woolworth—took just a few minutes to assemble, but Grandpa's tinsel project could go on for days.

Dad's family always had a big tree in the corner of the living room next to the front windows on 21st Avenue. Grandma had been saving decorations her whole life, and some ornaments still had candlewax drippings from when they were in use when she was a girl growing up South-of-Market in the 1880s. The tree had just a few strings of lights, as the old cords were wearing out, and Grandma was not one to change her traditions easily. In one of my favorite photos, she is sitting on the floor in front of the tree, looking quite elderly (though a full year younger than I am today, and she lived another twenty healthy years), just as World War II was beginning. Out of a dark background shines the enormous tree, along with her silent sense of satisfaction that as long as Christmas was coming, all would be right in the world. So long ago…so far away.

My parents initially had a medium-sized tree that they had flocked at the old Hallowell's Nursery (a modernistic-looking 1940s place with dark-blue exterior glass walls) at the northeast corner of 19th Avenue and Sloat Boulevard—where the Masonic Auditorium has stood since 1963. It was a nice look, but the flocking quickly dropped off, making more of a mess than real snow, especially once I began toddling around in 1952. After that, we had a non-messy artificial tree, made up of thin white leaves and lit by two spotlights on the floor.

In 1959, we had the inevitable aluminum tree exactly once, still lit by those two spotlights. We never did try the "color wheel" used by many, as orange and blue just didn't seem to fit the mood. By 1960, we were back to the white artificial tree, and Mom began to run wild with tiny clear lights, saying each year, "I think I'll add just one more string this year." I'm certain that PG&E experienced power surges each time our tree was plugged in.

In the early 1970s, my parents bought a massive artificial green tree that required each and every branch (there were 144 of them in twelve different sizes) to be inserted into the trunk in exactly the right spot, and getting this monster standing took the better part of a full day. Mom was still into tiny clear lights, and Dad expressed his preference for gold ornaments, so for the rest of their days, that was my parents' signature tree, in University of San Francisco colors of green and gold. A few years after Dad's passing in 1980, I managed to convince Mom that a *real* tree, about four feet tall and set

West Portal merchants decorated the façade of the Twin Peaks tunnel for Christmas of 1959. *Jack Tillmany Collection.*

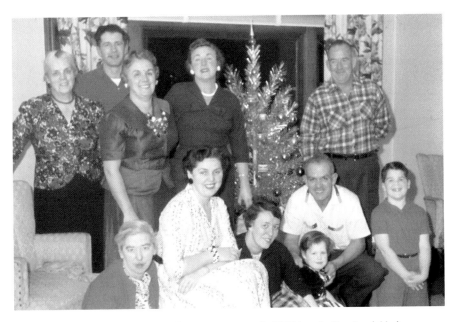

The aluminum Christmas tree made an appearance in 1959 but declined quickly in popularity. *Author's collection.*

atop a three-foot table, was just what she needed, and my life at Christmas became much easier!

For my own homes, I've always favored fresh green trees, with multicolor lights and a wide variety of ornaments, with no two alike—a legacy of my more than twenty-five years working in the retail industry and countless day-after-Christmas sales.

Even our next-door neighbors, who were Jewish (though members of a fairly lenient Reform congregation), always displayed an enormous "Hanukkah bush" in their front window, decorated with a variety of nonreligious ornaments such as reindeer, bells and snowflakes and topped with a silver-and-blue Star of David. Their household mantra during December was a stern, "Nobody tells Grandma." Even our few nonreligious neighbors were right there with pinecone wreaths, poinsettias, smiling Santa faces and an abundance of outdoor lights, proving that while Christmas has some clear religious origins, it has also evolved into a universal winter holiday.

Certain items were on display, from early December until the coming of the Wise Men on January 6, and I still use these items as holiday décor today:

- The pinecone in a small Dixie cup of solidified plaster of Paris, decorated by me with tiny beads and glitter in Mrs. Beckerman's 1957 kindergarten class at Parkside School.
- The manzanita branch from Uncle John, circa 1955, set on the dining room table and decorated with handmade snowflakes and tiny papier-mâché birds.
- The small three-dimensional Nativity scene of printed cardboard on which Mom had lovingly written on the back, "From my breakfast tray at St. Mary's Hospital—December 25, 1951, just after Frankie was born."

The neighborhood shopping streets—Taraval, West Portal, Irving, Clement and so on—were decorated with holiday wreaths, bells, holly and tinsel, strung from light poles and MUNI wires beginning the week of Thanksgiving. Even the façade of the Twin Peaks Tunnel was set up to resemble a fireplace, with hung Christmas stockings. When we went to visit relatives in the Excelsior—just beyond the far reaches of the Outside Lands—outer Mission Street had a unique look with large "Mission Bells" made of a thin red plastic material, swinging from the overhead MUNI lines. There was no mistaking it: Christmas had arrived in San Francisco.

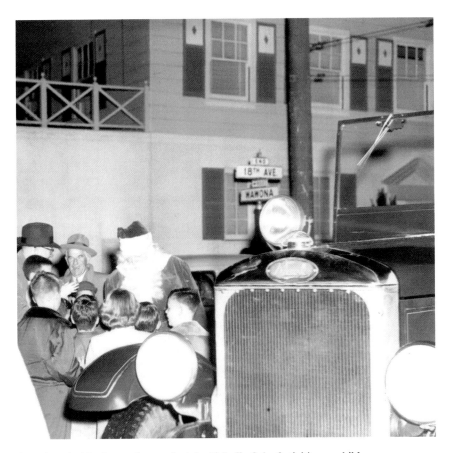

Santa's arrival by fire engine marked the kickoff of the festivities, as children came running to line up, December 1950. Crowds numbered in the hundreds annually for nearly twenty more years. *Christine Meagher Keller Collection.*

At home, Mom would be stockpiling ingredients for her Chex Mix as we eagerly awaited the "Night of the Lighting," always on a Saturday in mid-December—a tradition that began when the homes on our block were new, in the 1930s. Started by twenty-eight-year-old Cal Meagher and his wife, Doris, a young couple with a baby, the festivities continued until the 1960s, and the Meaghers remained active participants in the annual event, as well as 18th Avenue residents for the next fifty or more years. Santa would arrive, courtesy of a San Francisco Fire Department engine, and then be seated on his "throne" in the garage entrance of the resident-elected "mayor" for the year; he would listen to everyone's wish list and distribute candy canes.

This was also the night that my grandmother took us out for an early dinner at the Hot House so that Mom's party preparations in the kitchen were not disturbed. Mexican food, salt spray, twinkling lights and the sounds of Playland still remain indelible Christmas memories for me.

Once we returned home, the festivities began—neighborhood-wide open houses, with parents, kids, classmates, relatives and friends all joining together in a wonderful block party that spilled in and out of every home. Eggnog flowed as we all speculated about what Santa might bring to each of us, as well as what we were giving to our family members. We truly knew all of our neighbors then, and many of those friendships continue to this day.

On December 1, 1949, *San Francisco Call-Bulletin* columnist Jack McDowell reported that the tradition of outdoor holiday lighting had spread to Sylvan Drive near Sloat Boulevard, with the 18th Avenue residents helping their neighbors a mile or so to the southwest to learn the logistics of organizing such an event. The columnist noted wistfully, "The result was beautiful—in more ways than one. The block not only was decorated, with every home co-operating, but neighbors found more friendship than they ever guessed could exist on a single block." Amen, Jack McDowell, wherever you are!

As the holiday drew nearer, Christmas cards began arriving—often with two daily mail deliveries. Each envelope contained notes from family and friends that provoked memories and reminiscences, and my parents read the notes and letters aloud as we sat down to dinner so that everyone knew who was doing what. After Dad died in 1980, Mom continued corresponding with his remaining World War II navy buddies and their widows, and I maintained those contacts after Mom's passing in 2002, until the very last correspondent died just a few years ago. Like many families, we displayed cards on the mantel, end tables and around mirrors and even hung them from a string between two light sconces above the couch. When postage was four cents, people just sent more cards. Just like West Portal Avenue, there was no mistaking that it was Christmas when you arrived at our house—tall cards on the mantel, fold-over cards on a string between the wall sconces above the couch and smaller cards filling a basket.

Some of our other annual traditions included a visit to Santa and going on the Roof Rides at the Emporium on Market Street, seeing the tree under the dome at the City of Paris at Stockton and Geary, walking through the floral-and-lights displays at Podesta-Baldocchi Florist on Grant Avenue, collecting canned food for the needy, visiting the live Nativity scene at Lindley Meadow in Golden Gate Park and celebrating Hanukkah with our Jewish neighbors.

Top: Visiting Santa at the Emporium on Market Street in the mid-1950s. The store's "roof rides" were also an annual attraction from the late 1940s through the early 1970s. *Christine Meagher Keller collection.*

Left: Naughty or nice? Another visitor meets with Santa at the Emporium on Market Street, 1956. *Author's collection.*

Holiday celebrations were especially festive in the postwar years. *Christine Meagher Keller Collection.*

Families with small children always opened their presents on Christmas morning, with happy smiles captured in black-and-white photos, showing everyone bundled up in new bathrobes and PJs. As we grew older and began spending more time away from home during high school and college, many families had a subtle shift in the festivities and began opening presents on

Christmas Eve. Our family adapted to this quickly, and Mom declared that Christmas Eve dinner would be simple: hors d'oeuvres and dessert, with present-opening in between the two courses—that plan worked well for decades. The adults were then ready for bed as the younger generation headed off to Midnight Mass at St. Ignatius Church—indulging in both the religious and social aspects of the event. While the parents were at church the next morning, many of us now-adult offspring would prepare a festive breakfast—in our house, it always included Grandpa's favorite Polish sausage—to be served when the folks returned home.

Gifts were never of the extravagant variety that retailers suggest today. No one I knew ever received a set of car keys or costly electronics. The biggest childhood gift was usually a bicycle, although most were smaller items—toys and boxed games, clothing and homemade food treats.

Like most men of that era, Dad tended to give Mom totally practical things, and old photos demonstrate this clearly, showing a set of new kitchen dishes one year, a card table and chairs another time and, once, even a vacuum cleaner—oh, how she must have loved *that*! Mom also gave Dad what he liked and wanted—cartons of Kool menthol filter cigarettes, Old Spice or Aqua Velva aftershave and his annual subscription to *TV Guide*.

Over the next few days, we always had a steady stream of visitors—old friends, distant cousins and Mom's many aunts and uncles—who would drop by for a visit and some eggnog. Small dishes of peppermints, along with Chex Mix and the ever-present See's candy kept everyone satisfied from one meal to the next, as thick bayberry candles scented the air. Our old family friend Martha would always deliver a large box of her homemade cookies, with row after row of different varieties—chocolate chip, oatmeal-raisin, Mexican wedding cakes, lemon thins, gingerbread people, anise, orange and frosted cookies in cut-out shapes of trees, stars and candy canes—all nestled in layers of wax paper, providing tasty desserts well into the New Year. As I sat back, listening to the threads of conversation with so many people, it helped explain the story of how our family came to be exactly who and where we were.

Today, many of those who shared our Christmas festivities in the past are no longer with us, and I find myself celebrating with my cousins in Colorado or on the East Coast. Yet the nostalgic elements of the season remain, as clear as those twinkling lights that once glowed so brightly up and down dear old 18th Avenue.

Chapter 19

THE DIASPORA OF THE BORN AND RAISED

Diaspora: the movement of a large group of people to a place far from their ancestral homelands; origin: Greek; dispersion—from diaspeirein—to scatter; first known use in 1881.

There has been much talk recently about how San Francisco has changed, and indeed it has. However, we are most certainly *not* the first generation of native-born to experience drastic changes to our place of birth. The present-day complaints voiced by so many are merely the latest in a long list of issues experienced by every generation of locals, going all the way back to the native peoples who inhabited the area for centuries before the first European explorers and settlers.

The expeditions of Spanish explorers Cortés and (later) Ulloa, both in the early 1500s, certainly set the stage for significant changes in the lives of many Miwok, Modoc, Ohlone, Pomo and other native peoples. The Spanish Crown began to assert claims in northern California as early as 1542. Portuguese explorer Juan Rodriguez Cabrillo discovered San Diego Bay later that same year, claiming California for Spain. Distracted by other interests, however, the Spanish government did not focus on such remote colonies at the time.

In 1579, English explorer Sir Francis Drake claimed northern California for England, but no permanent settlement was established, thus weakening that country's claim to the area.

The expedition led by Gaspar de Portolà for Spain in 1769 was the first documented sighting of San Francisco Bay by Europeans. This discovery

led to significant Spanish colonization, as the Mission system was established between 1769 and 1833, largely by Father Junipero Serra. History tells us that the changes enacted by these early settlers were most certainly catastrophic for many of the indigenous people of the region, many of whom became forced laborers.

In 1812, Russian colonists established Fort Ross on the coast some sixty miles north of San Francisco. Although this land was claimed by England as a result of the Drake exploration, the area was never formally occupied, so the Russian settlers had little resistance when they asserted their claims. The northernmost of the Spanish Missions, located in Sonoma, was meant to halt any farther southward expansion into California by the Russians.

When Mexico's War of Independence with Spain began in 1810, there was decreased Spanish support for the Missions. Victorious by 1821, Mexico became independent from Spain, and in 1827, it passed the General Law of Expulsion, forcing all Spanish-born residents out of its newly acquired California. Beginning in 1833, many of the Missions were secularized, and some were sold off by the Mexican government. The Franciscans abandoned many of the sites, which then fell into disrepair.

Although France, a colonial powerhouse at the time, was thought to be interested in acquiring further colonies in the American West, no formal declarations were asserted.

By the early 1840s, San Francisco was undergoing further changes. Its isolation as a peninsula meant that most newcomers were arriving by ship around Cape Horn at the southern tip of South America, but in 1844, the first American settlers managed to cross the Sierras into northern California in covered wagons. They were followed two years later by the ill-fated Donner Party and, soon after that, by many thousands more.

The discovery of gold in 1848 transformed California virtually overnight from a relatively sleepy outpost to the vibrant center of a new civilization. As the result of the Mexican-American War, California was ceded to the United States, and statehood followed in 1850.

Just two and a half years earlier, in April 1848, San Francisco had fewer than two hundred buildings and a population of about one thousand. By the end of 1849, the population was up to twenty-five thousand and growing by four thousand new immigrants per month. If New York City was a melting pot of cultures, then so was San Francisco. All of a sudden, virtually no one was native-born, with most people having come from somewhere else— many from an eastern or midwestern state, northern Europe or the British Isles but also from Asia, the Hawaiian Islands and elsewhere. Riches were

to be made, and everyone who heard of this golden place at the continent's edge wanted to get in on the action.

When my own widowed great-great-grandmother left Ireland for America at the time of the Famine in the late 1840s, her new home in Washington, D.C., offered a step up from what she had left behind, but not by much. Signs proclaiming "NO IRISH NEED APPLY" were a standard fixture at many workplaces. When her son and one of his cousins set out for San Francisco in 1860, they must have been pleased to find a slightly more tolerant city on the far reaches of western America. The Irish Famine and that island's subsequent political climate prompted millions of other Irish natives to seek a new life in America, thus bringing about significant changes in many of the industrialized cities from coast to coast.

In addition to the population increase, fate and Mother Nature also provided other significant changes for the San Francisco populace. Between Christmas Eve 1849 and June 1851, the city experienced *six* major fires, which decimated the primarily wooden structures that composed the communities. Each time, the resolve of the remaining residents resulted in the rebuilding of a bigger and better city. Two significant earthquakes, one in 1865 and another just three years later, caused significant damage and emphasized the need for sturdier buildings and improved firefighting abilities.

The years of the Civil War and the 1869 completion of the transcontinental railroad—much of it built by Chinese laborers—brought about even more changes in the lives of millions of people. Technology, both then and now, has long been a contributing factor in shaping the lives of those who live on the West Coast of the United States.

The great waves of immigration from central, eastern and southern Europe in the late nineteenth century, as well as additional immigration from Asia, further changed the ethnic makeup of San Francisco. By the dawn of the twentieth century, San Francisco had become a series of small communities, each with its own history and culture—Nob Hill, South-of-Market, Chinatown and many others. These worlds mixed on Market Street, perhaps, but everyone went back to a specific part of town at dusk.

The events of 1906 brought about cataclysmic change, as tens of thousands of San Francisco residents, including one of my widowed great-grandmothers, sought new homes north, south and east of the city just as another wave of immigrants arrived (including another set of my great-grandparents in 1907) to help rebuild the infrastructure and businesses and to stake their own claim to the promises that California had to offer. Old areas such as South-of-Market changed, as other places

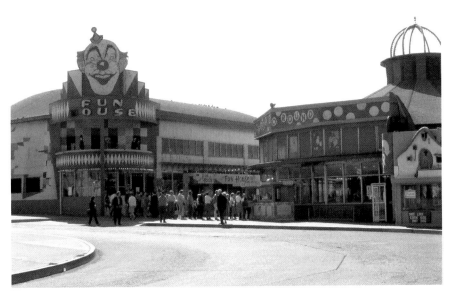

A visit to Playland was the ultimate carefree weekend afternoon for both children and adults for decades. *Dennis O'Rorke photo.*

like North Beach, Chinatown and Japantown became larger and more prosperous than ever before.

For many San Franciscans, the post-fire era was a golden age. Civic improvements were everywhere—a new Civic Center, expanded public transportation, new homes, schools, businesses and houses of worship. The automobile was in its heyday, and prosperity abounded—at least until October 1929. The Depression and the General Strike of 1934 hit many San Franciscans hard, but there was a gradual recovery as the 1930s drew to a close. It seemed that the good times were about to return—at least until that December weekend in 1941, when everything changed yet again.

Suddenly, San Francisco was an integral part of the war effort and, as some thought, perhaps also a target for enemy hostilities. Government-sanctioned imprisonments and the rise of defense-related industries brought about further changes in the racial and ethnic composition of many neighborhoods, as the government interned many law-abiding citizens. Thousands of war workers from the South left the fields and arrived to staff the shipyards and factories. The city that emerged at the end of the war a few years later was not at all the same as it was in 1941.

Returning GIs, anxious to start families, brought about the rapid development of the entire West of Twin Peaks area, all the way to the waters of the Pacific Ocean itself. Tens of thousands of new homes sprang up in a variety of communities that included both rentals and home ownership. Schools, houses of worship, civic infrastructure and neighborhood businesses quickly followed. The entire western side of San Francisco was transformed from sleepy sand dunes to a thriving community in less than a decade, with spillover extending into Daly City's new Westlake District, and many families moved even farther away to the Peninsula, the East Bay and Marin County.

Returning internees and war workers who liked living in California also sought permanent housing, and thousands of older homes in the Western Addition filled up rapidly, as some were subdivided into apartments and rooming houses. The new prewar low-rise community of Parkmerced suddenly grew with eleven new thirteen-story apartment towers scattered among the original townhouses. Nearby cabbage fields were transformed into the Stonestown Shopping Center in the early 1950s, with even more low- and high-rise apartment buildings. Adjacent open space was purchased by the State of California, and the modernistic structures of San Francisco State College sprang up, beginning in 1953. Mercy High School arrived in the Western Neighborhoods in 1952, followed by Lowell in 1962 and S.I. in 1969.

Times continued to change, and many baby boomers began coming of age in the mid-1960s. The Summer of Love in 1967, changing immigration laws, political instability overseas and San Francisco's willingness to embrace a variety of lifestyles brought many newcomers to the city and to the Western Neighborhoods from around the world.

Many younger people preferred something different for themselves and their new families—more living space, more sunshine and more places to drive and park the increasing number of automobiles that everyone seemed to be buying. Suburbs began to grow by leaps and bounds, and many San Franciscans began to enjoy homes that were located far beyond the city's official forty-nine square miles—well into the adjacent counties. In addition, with thousands of baby boomers completing college educations far from home, many resettled themselves in other parts of the country, knowing that transportation improvements could whisk them back to California quickly for various gatherings of family and friends. BART service, commencing in 1972, further contributed to the outward movement of many natives.

By the end of the twentieth century, everything from recreation to food, banking, worship and child care were very different from what they had

The 1966 Sutro's fire marked the beginning of the end for fun near the beach. Both Playland and Fleishhacker Pool would also close in the next few years. Fortunately, the land at Sutro's became part of the Golden Gate National Recreation Area. *Brad Schram photo.*

been earlier. Restaurant chains such as Doggie Diner, Fosters, Lyons, Red Roof, Zim's and Woolworth lunch counters had all disappeared. Even the popular Mama's, having expanded to eight locations throughout the Bay Area in the 1970s and 1980s, was scaled back in 1997 to just its original spot on Washington Square in North Beach.

The business climate has also continued to undergo equally dramatic changes. Gone are most of the solid union jobs in various manufacturing businesses—employment that provided stable income, family health benefits and solid retirement income to tens of thousands of San Francisco households. Bank of America, founded in San Francisco in 1904, is now headquartered in Charlotte, North Carolina, after a 1998 takeover, and thousands of jobs no longer exist in the Financial District. And who among us ever visits a bank to "cash a check" these days? Direct-deposit, ATMs and cash back with debit card purchases have significantly altered yet another regular routine, as well as thousands of associated jobs. Electronic securities registration by brokerage houses has eliminated stock transfer services that once employed thousands of people at local organizations like AT&T, Bank of America, Chevron, PG&E, Southern Pacific and Wells Fargo.

By 1971, the end was in sight for Playland. Dwindling crowds and a lack of maintenance were becoming more evident. *John A. Martini photo.*

Thousands of career customer service positions in retail, banking, insurance and public utilities are now handled by reps in remote telephone call centers on other continents, thus resulting in fewer local employment opportunities. The iconic AT&T building at 140 New Montgomery, built in 1925 and San Francisco's tallest building for nearly forty years, sat vacant from 2007 to 2013

following a series of mergers and acquisitions by the owner. Internet business reviewer Yelp is now the primary tenant, occupying 150,000 square feet on twelve floors, with no more telephone company operations present in the structure—a fact that shocks tens of thousands of AT&T retirees.

Malls, big-box retailers and online shopping have also contributed to a new appearance in the neighborhood shopping sections—places like California Street's Laurel Village, inner Clement and outer Balboa in the Richmond; Irving, Noriega and Taraval in the Sunset; West Portal; Lakeside Village; Stonestown; and the Ocean Avenue corridor near City College have all changed extensively, often for the better.

Hair and nail salons and stores selling cellphones are easy to find, although it's a bit trickier to find a good shoe repair shop, Danish bakery, hardware retailer or even a parking space. Grocery shopping, one of our most basic needs, is also very different today, following the entry by Costco, Walmart and even Amazon.com into the retail food business.

Schools have certainly changed over the past forty years or so. Polytechnic High, a revered institution with decades of sports championships, ceased to exist after 1972. Lowell's long-standing reputation for academic excellence, yet with physical limitations on enrollment even after its 1962 relocation to Eucalyptus Drive, continues to maintain a high standard of excellence and has also managed to foster strong academic improvements at several other public high schools.

Regular attendance at worship services has declined for many traditional congregations, leading to the closure and/or sale of several long-established churches and synagogues throughout the city, although dozens of prime corner building sites in many neighborhoods have been rebuilt with new houses of worship belonging to smaller congregations.

Some Catholic parishes, such as St. Brigid on Van Ness Avenue and St. Edward on California Street, are no longer in existence, and the buildings have been sold. Others, such as St. Thomas the Apostle on Balboa and St. Monica on Geary, operate with just one pastor overseeing two churches. Many Catholic churches in the Western Neighborhoods now offer services in Arabic, Burmese, Cantonese, Czech, Indonesian, Japanese, Korean, Mandarin, Portuguese, Spanish, Tagalog and Vietnamese.

Households with working parents have contributed to a significant increase in child-care facilities in every neighborhood. In particular, Catholic elementary schools built for the thousands of school-age children who lived in San Francisco in the 1950s now find themselves with dwindling enrollments and an excess of classroom space. Many, like Holy Name in the

Sunset, have now resurrected their kindergartens and have also established new preschool and after-school day-care programs, thus filling a pressing community need.

By the 1970s, many San Francisco Catholic high schools had begun changing, also due to the reduced number of children in the area. Star of the Sea, Presentation, St. Rose Academy and others faded from the scene, while some merged, such as the school now known as Sacred Heart-Cathedral. St. Ignatius (S.I.) High School, operating since 1855 as boys only, renamed itself College Prep upon its move to the Sunset in 1969 and then converted to coeducation in 1989. Today, it draws a full one-third of its students from outside San Francisco, has an ethnically diverse student population and is 50 percent female.

At the same time, communication and transportation improvements are leading more and more people to realize that San Francisco is a beautiful and desirable place to live. Technology industry employees in Silicon Valley noted the increasing housing costs there twenty years ago, and many began opting for living in San Francisco and taking what was once known as a "reverse commute" to work. Many of those same tech firms are now opening some of their facilities in the city itself, drawing even more workers into San Francisco. While this might be driving up the cost of living for all—it is simple supply and demand, after all—many of these changes have also contributed to the revitalization of city neighborhoods and a stronger tax base to support city services for everyone.

Just as in the past, there continues to be turnover among residents, and some of today's longtime residents are choosing to leave, while many who stay complain that things "are not the same as they used to be." There are no "right" or "wrong" decisions here—people have always had to choose a course of action that they think will be best for themselves and their loved ones, just as our ancestors have done over the last five hundred years or so of local history.

Looking back at the loss of Sutro's, Fleishhacker Pool and Playland-at-the-Beach more than forty years ago, we can see how one small change often leads to others. No one "forced" those three entertainment spots to shut down, and city government could not "save" them since they were privately owned businesses whose time had passed—the heyday for all of them was an era when transportation and entertainment options were far more limited. Also, if we look back honestly, there were some serious issues—gangs, crime and homelessness at Playland were all becoming concerns as the end approached. Safety was another sore point, given the wooden architecture and multiple

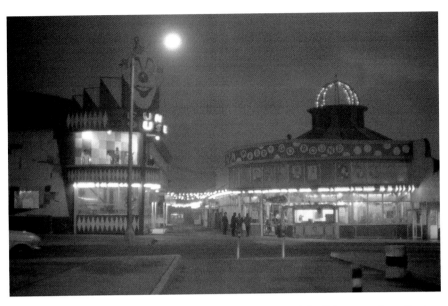

Labor Day weekend of 1972 marked the end of Playland, and the lights went down for the last time. *Dennis O'Rorke photo.*

fires over the years in and around a half-boarded-up Sutro's, while the cost of heating and filtering seawater for an outdoor pool at the beach became horribly prohibitive. General upkeep for structures being corroded daily by salt air was an enormous cost at all of these locations. Once the practice of deferred maintenance commenced because of dwindling attendance, it all became a downward spiral.

It should not be surprising that the coming of widespread automobile ownership, jet plane travel, Disneyland, major-league Bay Area sports teams, shopping malls, interstate highways, a population shift to the suburbs and easy credit all contributed, in varying small degrees, to create a scenario in which these once-popular places were no longer everyone's first choice for a day of fun. There was no hope of preserving the past because so many of the factors that once supported these places had already changed.

Even today, as we relax and reminisce with fond thoughts of the past, things are continuing to evolve around us. There is a new and vibrant mid–Market Street emerging, many run-down neighborhoods are being revitalized and public transit is being extended to communities in the city that were historically underserved. New and exciting places to eat, shop, walk, bike or simply relax are being added in every part of town—yet even

these seemingly positive changes may result in unexpected surprises for some current residents.

Just as our ancestors remembered and relished their own personal visions of a lost pre-1906 (or a pre-1941 or a pre-1963 or a pre-2000) San Francisco, we do the same with our own happy memories of the past. Then and now, however, all of us must sometimes be reminded to acknowledge and embrace the city's vibrant present as well as its future— perhaps by giving ourselves a gentle "reality check" with the soothing but clear words from the upbeat 1964 pop hit sung by Chad Stuart and Jeremy Clyde: *But that was yesterday—and yesterday's gone.*

For each moving van that pulls away from a neighborhood street, taking one of the "born and raised" to another home in a different city or state, a brand-new resident is arriving from elsewhere, via SFO, Interstate 280 or the Bay Bridge, and thinking, "This is it. This is where I'm going to put down my roots for a good long time!" That's the very same thought that was embraced by so many millions of our own ancestors twenty-five, fifty, one hundred or more years ago.

San Francisco will continue to flourish as a tiny, magical world of its own on the continent's edge, thanks to the strength, determination and loyalty of past, present and future San Franciscans.

Chapter 20

FACTS AND FIGURES

The widest street in San Francisco is Sloat Boulevard at 135 feet.

The busiest street in San Francisco is 19th Avenue with more than eighty-five thousand vehicles daily.

In 1940, there were 165,000 registered motor vehicles in San Francisco, versus 470,383 in 2010.

Until 1940, 19th Avenue in the Sunset was a standard width and was then widened to accommodate more traffic during the three years after the opening of the Golden Gate Bridge.

Until the late 1950s, Portola Drive was a narrow roadway with only one lane in each direction, from the Twin Peaks area to Sloat Boulevard, and many homes were removed for its 1950s widening.

———◆———

The old Market Street Railway operated its #17 streetcar line on 20th Avenue, from Lincoln Way to Wawona Street from 1916 to 1945, which is why that north–south avenue is wider than normal.

In the Sunset District, 30th Avenue was laid out wider than normal to accommodate a never-built streetcar line.

About 35,400+ vehicles enter the city during the Monday–Friday workweek.

Horses pulled the first streetcar up Market Street on July 4, 1860.

Today, MUNI has about 700,000 passengers board its vehicles every weekday.

The largest passenger volume on a MUNI line is the 38-Geary, with more than fifty thousand daily riders.

Streetcars ran on Geary from downtown to the Beach until 1956.

———

Today's biggest employer in San Francisco is city government, with 25,000 employees; second largest is the University of California Medical Center, with 22,000; and third largest is California-Pacific Medical Center, with more than 8,500.

The number of firms with one thousand or more employees has fallen by half since 1977.

Nearly 85 percent of San Francisco businesses employ ten or fewer people.

In the 1950s, children represented a full 25 percent of the city's population, and they often outnumbered the adults on many blocks in the Western Neighborhoods. In 2014, only about one in eight San Franciscans (12.5 percent) is under age eighteen.

———

More than seventy-five thousand students are currently enrolled at four San Francisco institutions of higher learning: CCSF, SFSU, USF and UCSF.

Tuition for Catholic elementary schools in the early 1960s was a mere six dollars per month per family—no matter how many children.

In the 1960s, St. Gabriel School at 41st Avenue and Ulloa had three classes of fifty students at each grade level (first through eighth), for a total enrollment of 1,200, making it the largest Catholic school west of the Mississippi River at the time.

Today, Archbishop Riordan High School offers both a day and a boarding program.

In the 1950s, San Francisco had fourteen girls-only Catholic high schools in operation, but today there are just three—Convent of the Sacred Heart on Broadway, Mercy High School on 19th Avenue and Immaculate Conception Academy (ICA) on Guerrero Street.

Thanksgiving Day prep football has been played at Kezar Stadium since the 1920s. One of the most exciting moments was the 1966 game between Lowell and S.I. The winning score came in the last thirty-one seconds of play when S.I. came from behind to beat Lowell, 21–14, leading one sports writer to pen, "AGONY and ECSTACY."

———————

San Francisco has more restaurants per capita (39.3 per 10,000 households) than any other city in the United States.

There are only 6.0 bars per 10,000 households, placing San Francisco at number eight nationwide, with New Orleans coming in at number one with 8.6 bars per 10,000 households.

In spite of many restaurant closures, some places serving food and drink in the Western Neighborhoods are still going strong fifty or more years after their opening:

> » El Toreador, 50 West Portal Avenue—50+ years
> » Manor Coffee Shop, West Portal Avenue—50+ years
> » The Philosophers' Club, Ulloa near West Portal—50+ years
> » Celia's, Judah near 46th Avenue—50+ years
> » Villa d'Este, Ocean Avenue in Lakeside Village—60+ years
> » The Gold Mirror, 18th Avenue and Taraval Street—60+ years
> » The Portals Tavern, West Portal Avenue—60+ years
> » Louis' Restaurant, Point Lobos Avenue—75+ years
> » The Little Shamrock, Lincoln Way—120 years!
> » The Cliff House, Point Lobos Avenue—150 years!

———➤◆◄———

SF's measurable snowfalls occurred only in 1882, 1887, 1932, 1951, 1962, 1976 and 2011.

SF's temperature seldom varies outside the range between 40° and 80° Fahrenheit.

SF's record low temperature was 27° on December 11, 1932, and the record high was 103° in 1988 and 2000.

———➤◆◄———

San Mateo County was once part of San Francisco (1850–56) before being split off.

San Franciscans have often gone to San Mateo County for various products and services:

> » Fourth of July fireworks (illegal in San Francisco)
> » Westlake's A&W—always *the* place to be on Friday nights in the late 1960s
> » San Francisco International Airport and the Cow Palace indoor arena
> » For more than thirty years, Brisbane was home to San Francisco's solid-waste landfill
> » Since 1934, the San Francisco County Jail has been located in San Bruno—with a new facility since 1996
> » San Francisco's water supply at Crystal Springs Reservoir
> » One of the Bay Area's oldest bars, Coattail Molloy's, in Colma (the building went up in 1883)
> » The last of local drive-in movie theatres—Mission, Geneva, Spruce and El Rancho—were all demolished long ago
> » Virtually all the local cemeteries are now located in the town of Colma

———➤◆◄———

From the time before the California Gold Rush, the native-born population has often been at odds with newcomers.

In 1900, 34 percent of San Franciscans had been born abroad. In 2000, the figure was only 36 percent.

San Francisco's population reached an all-time high of 775,357 in 1950 and then began a steady decline, reaching 678,974 in 1980.

A decade before the turn of the millennium, the city's population began to rise once again: 723,959 (1990), 776,733 (2000), 805,235 (2010) and 837,442 (2013).

———◦———

Some significant San Francisco architectural losses since the mid-twentieth century:

> » Montgomery Block, 1959
> » Fox Theatre, 1963
> » Sutro Baths, 1966
> » Fleishhacker Pool, 1971
> » City of Paris, 1972
> » West Portal façade of Twin Peaks tunnel, 1976
> » Parkside School, 2004

———◦———

Some spectacular survivors at age one hundred or more:

> » cable cars
> » City Hall
> » Cliff House
> » Conservatory of Flowers
> » Contemporary Jewish Museum (rebuilt Jessie Street power substation)
> » Earthquake Shacks
> » Emporium's Dome (rebuilt)
> » Haas-Lilienthal House
> » Fairmont Hotel
> » Ferry Building
> » Flood Building
> » Francis Scott Key Monument
> » Golden Gate Park Windmills
> » Lotta's Fountain
> » Mills Building
> » Mission Dolores
> » Neptune Society Columbarium

» Old Main Post Office
» Old St. Mary's
» Pacific Union Club
» Palace Hotel
» Palace of Fine Arts (rebuilt)
» Presidio Officers' Club
» St. Francis Hotel
» St. Francis of Assisi Church
» St. Ignatius Church
» St. Patrick's Church
» Temple Sherith Israel
» Victorian houses

On the critical list for preservation:

» Alexandria Theatre
» Doelger Office Building
» Old Commerce High School
» Hibernia Bank Main Branch
» Mother's House at the San Francisco Zoo
» Old Mint

The San Francisco 49ers pro football team plans to open its 2014 season at Levi's Stadium in Santa Clara, some forty-five miles away.

The Golden State Warriors pro basketball team, once based in San Francisco, is now headquartered at Oracle Arena (aka Oakland Coliseum Arena) across the Bay in Oakland.

The Bay Bombers Roller Derby team, once a fixture at Kezar Pavilion in Golden Gate Park, now performs locally only in Santa Clara and Santa Cruz.

The Shipstads and Johnson Ice Follies performed at San Francisco's Winterland for several weeks every summer from the late 1930s until the late 1960s, but its merged entity, Holiday on Ice, no longer visits San Francisco.

The Ringling Bros. and Barnum & Bailey Circus arrived in San Francisco for a two-week stay every September, but today, the only Northern California engagement is three days in Stockton.

Many areas in the Western Neighborhoods held annual outdoor holiday lighting contests, including certain blocks of 16th, 17th, 18th and 28th Avenues; the first block of Sylvan Drive; and most of St. Francis Wood.

Major public Christmas trees included the top of Twin Peaks, the City of Paris rotunda, the Shriner's Hospital on 19th Avenue and McLaren Lodge at the entrance to Golden Gate Park from the Panhandle.

San Francisco is the most densely populated U.S. city after New York City and includes the following demographics:

> » The city's white population fell below 50 percent after the 1990 U.S. Census and was 48.5 percent in 2010.
> » The city's Asian population, about 13 percent in 1970, rose to 29 percent in 1990 and was more than 33 percent in 2010.
> » The city's black population has fallen from more than 13 percent in 1970 to just over 6 percent in 2010.
> » The city's Hispanic population has increased from almost 12 percent in 1970 to just over 15 percent in 2010.
> » San Franciscans who self-identified as being more than one race were nearly 5 percent of the population in 2010.
> » Estimates place the LGBT population of San Francisco at about 15 percent over the last decade.

As large as San Francisco is, it represents only 10 percent of the total 2010 Bay Area population of 8.4 million—in other words, 90 percent of the Bay Area population lives *outside* the City and County of San Francisco.

SELECTED BIBLIOGRAPHY

Alumni Newsletters

Future magazine, Archbishop Riordan High School.
Genesis, St. Ignatius College Prep.
George Washington High School Alumni Association Newsletter.
Lowell Alumni Association Newsletter.
Perennial Parrot, Polytechnic High School.
USF Magazine, University of San Francisco.

Archives

Archdiocese of San Francisco.
GLBT Historical Society.
Holy Cross Cemetery.
Prelinger Library.
San Francisco Public Library.
State of California Birth Index, 1905–95.

State of California Death Index, 1940–97.

Western Neighborhoods Project.

BOOKS

Brandi, Richard. *San Francisco's West Portal Neighborhoods.* Charleston, SC: Arcadia Publishing, 2005.

Burchell, R.A. *The San Francisco Irish, 1848–1880.* Berkeley: University of California Press, 1980.

Caen, Herb. *Don't Call It Frisco.* New York: Doubleday, 1953.

———. *Only in San Francisco.* New York: Doubleday, 1960.

Garibaldi, Rayna, and Bernadette C. Hooper. *San Francisco Catholics.* Charleston, SC: Arcadia Publishing, 2008.

Issel, William, and Robert W. Cherny. *San Francisco, 1865–1932.* Berkeley: University of California Press, 1986.

LaBounty, Woody. *Carville-by-the-Sea.* San Francisco, CA: Outside Lands Media, 2009.

Martini, John A. *Sutro's Glass Palace: The Story of Sutro Baths.* Bodega Bay, CA: Hole in the Head Press, 2013.

McGloin, John B., SJ. *Jesuits by the Golden Gate.* San Francisco, CA: University of San Francisco Press, 1972.

Polk's Crocker-Langley San Francisco City Directory. Various editions.

Smith, James R. *San Francisco's Playland at the Beach: The Golden Years.* Fresno, CA: Craven Street Books, 2013.

Tillmany, Jack. *Theatres of San Francisco.* Charleston, SC: Arcadia Publishing, 2005.

Totah, Paul. *Spiritus Magis.* San Francisco, CA: St. Ignatius College Preparatory, 2005.

Ungaretti, Lorri. *San Francisco's Richmond District.* Charleston, SC: Arcadia Publishing, 2005.

———. *San Francisco's Sunset District.* Charleston, SC: Arcadia Publishing, 2003.

———. *Stories in the Sand.* San Francisco, CA: Balangaro Books, 2012.

Works Progress Administration, Federal Writers' Project. *San Francisco in the 1930s.* New York: Hastings House, 1940.

Internet Sites

Arden Wood Christian Science Community. www.ardenwood.org.
Congregation Beth Israel Judea. www.bij.org.
Congregation Emanu-El. www.emanuelsf.org.
Curbed SF. www.sf.curbed.com.
Found SF. www.foundsf.org.
Guidelines. www.sfguides.org/public_guidelines.
Holy Name Parish. www.holynamesf.org.
Holy Trinity Greek Orthodox Church. www.holytrinitysf.org.
Holy Virgin Russian Orthodox Cathedral. www.sfsobor.com.
Lick-Wilmerding High School. www.lwhs.org.
Mercy High School. www.mercyhs.org.
Pine United Methodist Church. www.pineumc.org.
San Francisco Fire Department. www.guardiansofthecity.org.
San Francisco Genealogy. sfgenealogy.com.
San Francisco Recreation and Parks Department. www.sfrecpark.org.
Scottish Rite Masonic Center. sfscottishrite.com.
St. Anne's Home. www.littlesistersofthepoorsanfrancisco.org.
St. Cecilia Parish. www.stcecilia.com.
St. Francis Episcopal Church. www.stfrancisepiscopal.org.
St. Ignatius College Preparatory. www.siprep.org.

Newspapers

Catholic San Francisco.
J. [*Jewish News Weekly of Northern California*].
San Francisco Chronicle.
San Francisco Examiner.
San Francisco News-Call-Bulletin.
San Mateo Daily Journal.

Published Articles

Brandi, Richard, and Woody LaBounty. "San Francisco's Ocean View, Merced Heights, Ingleside Neighborhoods, 1862–1959." Historical Context Statement, San Francisco Mayor's Office, 2010.

———. "San Francisco's Parkside District, 1905–1957." Historical Context Statement, San Francisco Mayor's Office, 2007.

Nolte, Carl. "In Search of Native-Born San Franciscans." *San Francisco Chronicle*, January 11, 2009.

Pastorino, Robert S. "Poly-Lowell Football, 1912–1971." *California Interscholastic Federation*, San Francisco Section, 1972.

INDEX

About the Author

Courtesy of Betty Lew.

Frank Dunnigan was born in San Francisco during the baby boom years of the 1950s to a family who had settled there in 1860. He graduated from St. Ignatius College Prep and the University of San Francisco and worked as a bank auditor and then as a retail training manager before joining the federal government. His monthly history column "Streetwise" has been published by the Western Neighborhoods Project (www.outsidelands.org) since 2009, and he has contributed content to local history books written by other authors. He is a recent retiree now living in Phoenix, Arizona.

Visit us at
www.historypress.net

···

This title is also available as an e-book